KT-115-796

PREFACE

Capturing a beautiful photograph isn't magic. It isn't even particularly difficult. You don't need a fantastic camera, an expensive lens, or a fancy flash. Start by thinking about why you want to take photos in the first place. Let me guess: you spot something beautiful, something that makes you feel something, and you want to share it with the world.

I want to let you in on a secret: that's why we all take photos! And here's another one, just for free: we can all be better photographers, yes even the pros. Whatever your photographic

WHY PHOTOGRAPHERS PREFER CLOUDY DAYS

AND 61 OTHER IDEAS FOR CREATIVE PHOTOGRAPHY

HAJE JAN KAMPS

ilex

An Hachette UK Company
www.hachette.co.uk

First published in Great Britain in 2017 by
ILEX, a division of Octopus Publishing Group Ltd

Octopus Publishing Group
Carmelite House
50 Victoria Embankment
London, EC4Y 0DZ
www.octopusbooks.co.uk
www.octopusbooksusa.com

Distributed in the US by Hachette Book Group
1290 Avenue of the Americas, 4th & 5th Floors
New York, NY 10104

Distributed in Canada by Canadian Manda Group
664 Annette St., Toronto, Ontario, Canada M6S 2C8

Publisher, photography: Adam Juniper
Managing Editor: Frank Gallaugher
Senior Editor: Rachel Silverlight
Art Director: Julie Weir
Design: JC Lanaway
Cover Design: Made Noise
Production Controller: Meskerem Berhane

ISBN 978-1-78157-454-6

A CIP catalogue record for this book
is available from the British Library

Printed and bound in China

10 9 8 7 6 5 4 3 2 1

CONTENTS

ambitions, I've aimed to give you some ideas about how to be more creative in your photography—as well as some tips to help you avoid the basic mistakes we all make from time to time.

The purpose of this book isn't to help you take photos. It's to help you tell stories with your images. That's where the magic lives. That's where the best photos come from.

Pick up your camera or your smartphone, and let's do this!
Haje Jan Kamps

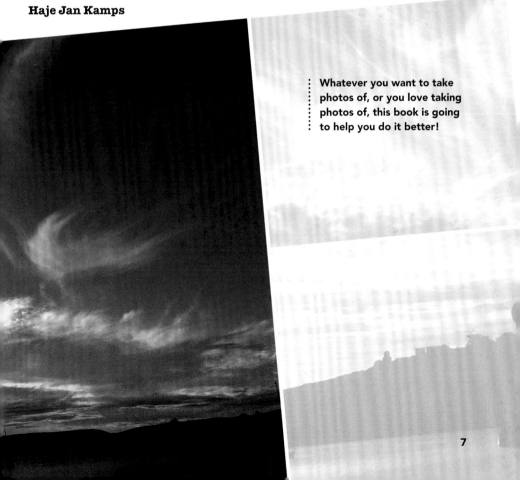

Whatever you want to take photos of, or you love taking photos of, this book is going to help you do it better!

PART ONE
CLICHÉS &
CLEVER TRICKS

It's commonly accepted that you should avoid clichés "like the plague." I think that's a dumb rule. There's a reason why certain images are so often repeated, and it's because those photos really work. As a way of learning photography in the beginning, or for practice as you're improving your photography skills, you can't go wrong with a good old cliché.

In fact, I'd argue that trying to nail a photo you really enjoy is a good way of learning about photography in general. Who cares if a sunflower field with a fluffy-cloud-dappled blue sky has been done before? Doing it well is legitimately hard. Getting it right means you've learned something.

Of course, if you're able to bring something new to those tired concepts, all the better. The next time you're in a furniture or home decor shop, go look at the photography section there. Most of it is tasteful but utterly boring. That's a great jumping-off point for figuring out how you can develop your own photographic eye. What makes those photos boring? How can you do better?

I say, embrace the clichés: they represent a hundred years or so of photographic history. The challenge is all about finding a new angle—and I've got some suggestions for that, too...

01 FLOWERS

Photographing flowers well is all about following these three simple steps:

1. Find the perfect specimen. Once you really start looking, you'll probably discover that few flowers are flawless, but for photographic purposes, that's exactly what you'll want—unless of course for your purposes the "perfect specimen" means "perfectly flawed," like the withered rose opposite.

2. Check out the background. Now that you have your perfect flower(s), it becomes all about context. There are three ways you can go here: Photograph it its natural setting, take it out of context and place it on a perfect white (or colored) background, or do something wildly contrasting.

3. Get the focus right. I know we were just talking about the background, but now it's time to cast your eye back to the main subject again. If your flower isn't in perfect focus, you're not telling the story of the flower, but of everything else around it.

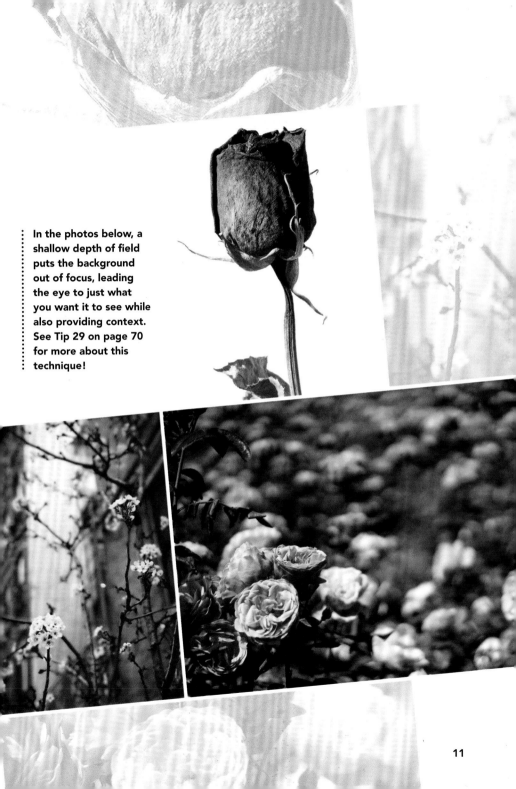

In the photos below, a shallow depth of field puts the background out of focus, leading the eye to just what you want it to see while also providing context. See Tip 29 on page 70 for more about this technique!

The key thing to remember about shooting sunsets is that your camera or phone will measure the amount of light in the entire scene, and it will tend to overexpose the photo, bleaching out all the color into pale blandness. The most dramatic thing about sunsets is usually the colors, so you'll want to underexpose slightly to properly capture them. On a phone, you can usually help your device by touching on the brightest part of the scene to tell the camera expose for it. On a camera, use the exposure compensation dial to underexpose by about ⅔ stop.

The reason you want to underexpose (that's photo language for making the photo too dark) is that the colors in your sunset will look a lot better than if they're washed out due to overexposure.

If you edit your photos (you should!), increase the saturation a little bit to really bring the scene to life. And if you want to get fancy, try to get something in the foreground, too. Silhouetting something (or someone) interesting against a sunset makes for an eye-catching image!

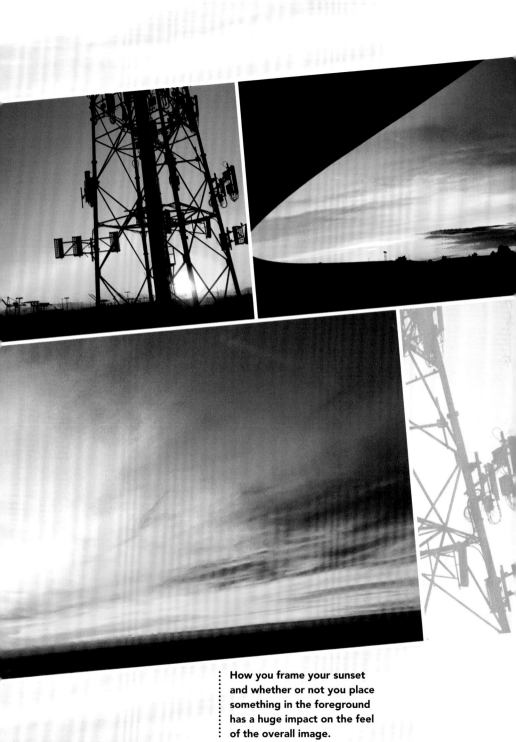

How you frame your sunset and whether or not you place something in the foreground has a huge impact on the feel of the overall image.

03 | PETS

To capture your pets at their best, use what you know about them. For example, some cats love to sleep in a particular spot; set up your camera gear in that area before they doze off, and you're ready to shoot when they're ready to sleep. After all, a sleeping cat is the easiest kind to photograph!

Having said that, the movement of pets is often even more exciting. The trick here is to think of your pet as if they're a person. (Let's admit it—we all do that anyway.) Capture something about their personality to help tell the story of who they are. If you're struggling to come up with something, just play with your furry friend. They'll love you for it, and trust me, inspiration will strike soon enough.

As with any portraiture, it's all about the eyes. Getting the eyes in focus properly (and ideally, getting eye contact with the camera) makes for memorable pet photos.

CLICHÉS & CLEVER TRICKS

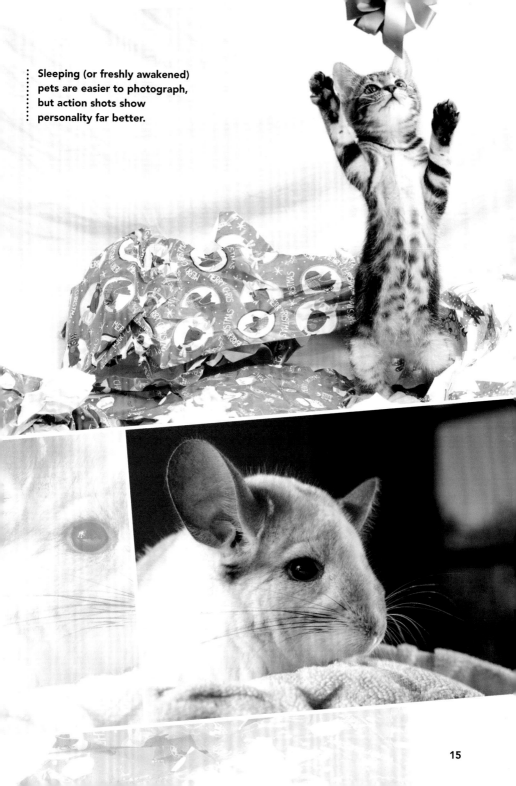

Sleeping (or freshly awakened) pets are easier to photograph, but action shots show personality far better.

In my book, black and white is a shortcut to awesome. You can point your camera at almost anything, strip away the color, and make it look artsy. That doesn't mean you should, though. Think about what the absence of color adds to your story before you go down that road.

I always feel that black and white adds a lot to a scene where colors can be assumed. A green forest, a yellow flower, or a red fire hydrant make for interesting color images, of course, but strip the color away and what are you left with? Shooting in black and white helps me think about composition, texture, and the interplay of light and dark.

On a lot of mobile phones, you can get a live preview of what a scene would look like in black and white. It's a perfect tool to practice with and to figure out what works and what doesn't. Don't be shy—try it out!

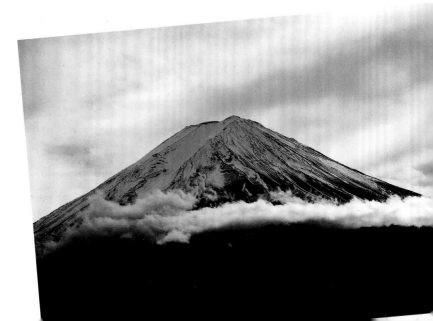

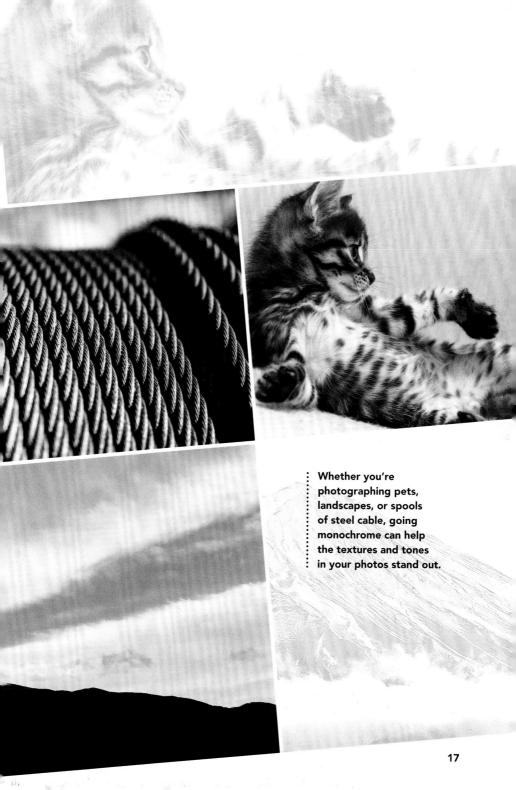

Whether you're photographing pets, landscapes, or spools of steel cable, going monochrome can help the textures and tones in your photos stand out.

SELECTIVE
COLOR

Imagine a mostly black-and white photo of a New York City street scene where the only color is the yellow of the taxi cabs. Or a photo of a London street where all colors are stripped away except the iconic red of the double-decker buses. Well, you wouldn't be the first to imagine that; it's been done to death! Don't let that stop you, though; selective color use can look fantastic. There's a reason it's been done so much.

There are tons of apps out there for iOS and Android that do the hard work for you. Color Splash, Color Blast, and Color Pop are among the better-known ones, but do a quick search for "selective color" and you'll find dozens.

Selective color techniques work best on photos that have small areas of a single, continuous color. Think buses and taxis, a basket of apples, a woman in red against a cityscape or a snowy scene, or a single yellow flower in a field of blue ones... Get creative and try out different subjects.

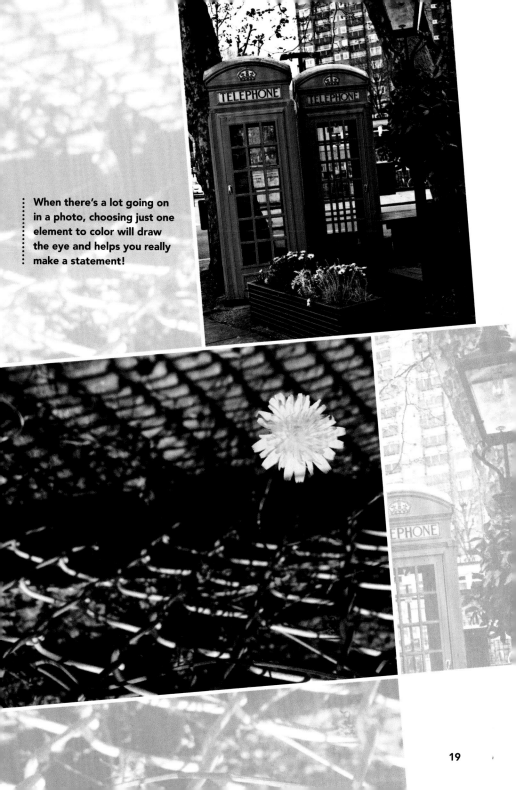

When there's a lot going on in a photo, choosing just one element to color will draw the eye and helps you really make a statement!

06 WONKY ANGLES

Every photography book will tell you to get your horizons nice and straight. There's something to that. If the horizon is almost straight but not quite, the image will look really sloppy; so, if it looks like it should be straight, turn on the "guidelines" setting and make sure it's perfect.

But, on the other hand, why bother? You're here to create eye-catching, dynamic photos, right? So why not get wonky with those lines. Shoot a building at 45°, or try shooting a portrait at a funky angle. Break up the preconceived ideas people have of what a photo should be.

There are no unbreakable "rules" in photography, so go wild and explore, and find out what you like! Take photos from up high, down low, and cut half of your subject's faces off if you feel like it (with the camera angle, of course, not literally).

Sprinkle some drama and add a dynamic feel to your images by throwing the horizon way, way off.

07 GET CREATIVE WITH LIGHT SOURCES

Fun fact: "photography" literally means "drawing with light." Makes sense; light is the single most important ingredient in your photography. If you have beautiful lighting, you can take fantastic images with a five-dollar disposable camera. If the light is bad, a $100,000 studio camera can't save you. To advance your still-life and portrait photography, don't worry about spending money on camera equipment. Instead, learn how to make the most of the light you have available.

Get yourself some colored acetate sheets. Placing these in front of a light source can create some really cool color effects that'll add pizazz to your photos. (Be careful not to place the sheets too close to the light, though, lest the plastic catches fire or melts.) Alternatively, try using things like Christmas tree lights or electroluminescent wire to add some creative flair to your lighting.

Using LEDs, laser pointers, and electroluminescent wire can add a fun dimension to your photography. Try it out!

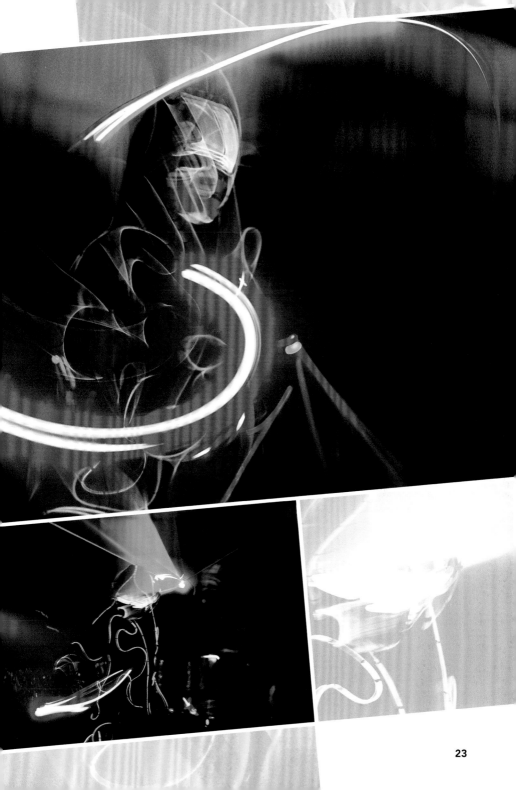

PAINT WITH LIGHT

Exposure is a powerful tool. Short exposures can capture a subject in motion with pin-sharp clarity, but shooting with long exposures can produce some really cool, creative effects. One of my favorites is using a long exposure and a light source to literally draw with light! Here's how you do it:

Set your camera to a suitably long shutter speed (10 seconds or more works great), using a tripod, and use a flashlight to draw something in the air. Because your camera is capturing the whole duration of the exposure in a single shape, you can write rude words in the air, and they will be readable in the image. Okay, so you don't have to beam obscenities into the world; the technique works for nice words and fun shapes, too.

Finally, you can use the same trick to light up large objects. With a bit of practice, you could paint a deserted barn or a car with light. Experiment, have fun!

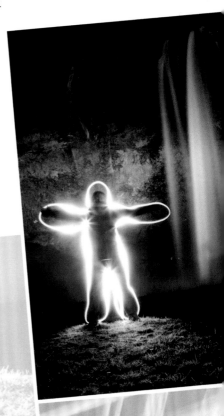

These three very different examples of light painting were all done using the same technique.

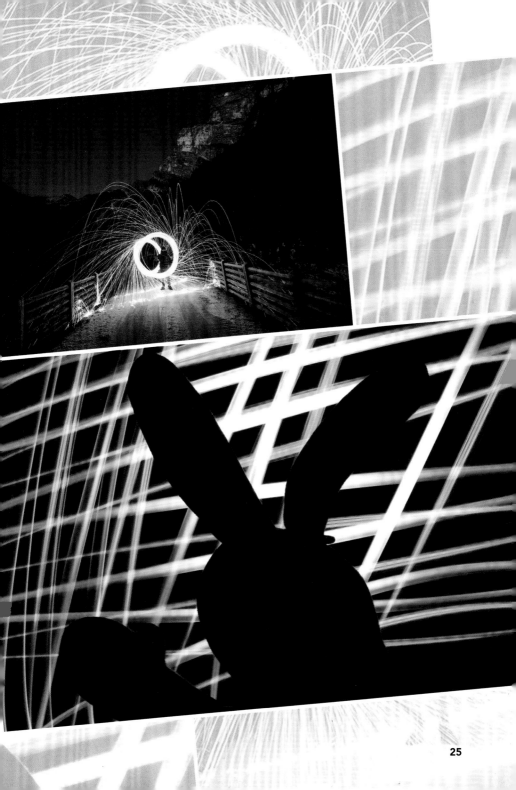

09 EYE CONTACT, OR NOT?

When you're looking at television news, you'll often see someone speak to an interviewer just off the side of the camera. In this setup (called an over-the-shoulder shot), you feel close to the action, without really being part of it. In drama, you'll sometimes see actors speak directly to the camera. It feels a little uneasy (and is known as "breaking the fourth wall"), but can be a really powerful storytelling technique. The final option is to move the camera off to the side, so you can see two people having a conversation. The camera is just documenting at this point, without really being part of the action.

As a photographer, you have access to all of these techniques. Mix them up. The cheesy, head-on grin may be the biggest cliché if all, but good eye contact with a model in a portrait can be really powerful. Feeling as if you're observing a candid moment can be, too. It depends on the context and the mood of the photo. Try experimenting with both!

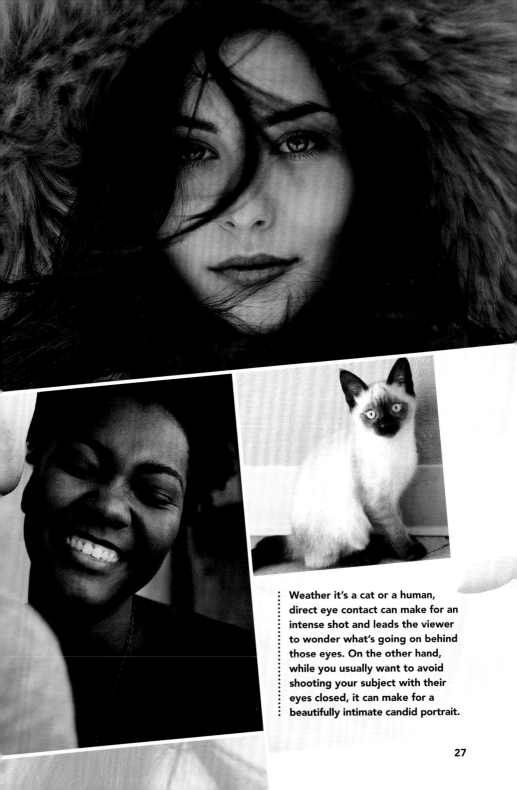

Weather it's a cat or a human, direct eye contact can make for an intense shot and leads the viewer to wonder what's going on behind those eyes. On the other hand, while you usually want to avoid shooting your subject with their eyes closed, it can make for a beautifully intimate candid portrait.

27

10 LOOK OUT OF THE FRAME

"Look at the camera and smile," is a pretty standard instruction to your models, but it's hard to get creativity into shots like that. So, let's try the opposite! Ask your models to gaze out of the frame. The easiest way to give that instruction is to find something interesting outside the frame, and instruct your model to look at it.

At the very least, looking out of the frame helps the photos seem a little less staged, but if you get it right, your model's expression and pose can help tell the story. Are they looking away from you? Are they seeing at something interesting, disgusting, intriguing, or sad? Are they lost in thought or contemplating something in particular?

To practice this tip, ask a friend to curl up on the sofa and read a book. Instruct them to ignore you, and snap away. Easy!

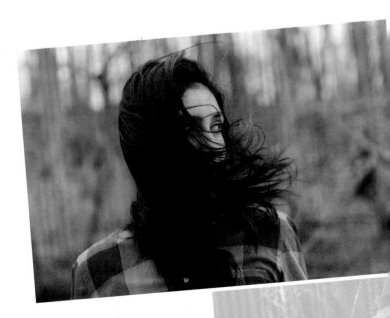

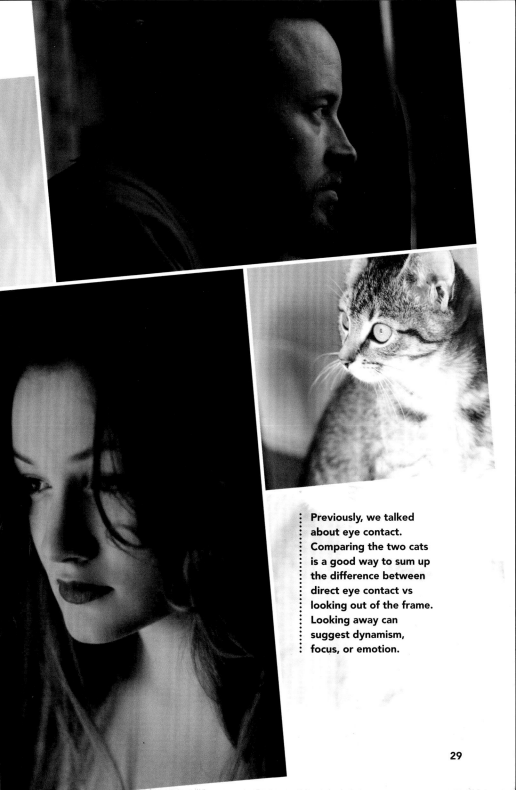

Previously, we talked about eye contact. Comparing the two cats is a good way to sum up the difference between direct eye contact vs looking out of the frame. Looking away can suggest dynamism, focus, or emotion.

PART TWO

TELL A STORY

Anyone can snap a photo. The challenge is to make your audience think, experience an emotional response, and be able to read a story from your photographs. Storytelling, above anything else, is a crucial part of photography. It's the one thing that elevates a good photo to a great one. It's also one of the hardest things to do. So where do you start?

I'll show you how to become a visual storyteller, and by practicing these tips you'll have a clearer picture of who you are taking pictures for and how you can use context, focus, and a bit of planning to help tell the stories you want to tell.

CONTEXT IS EVERYTHING

How do you know whether the person you've photographed in a white coat is a doctor, a scientist, or an artist? You don't, unless you add a layer of context. An operating room, a set of bubbling beakers, or a fist full of paintbrushes—these details don't tell the whole story, but they do help add context to your imagery.

That rule isn't true only for portraits, of course. Context is crucial in most storytelling. If you watch a TV show, almost every new scene starts with an "establishing shot" of the outside of a building or some other location. Why? What do you care what the building looks like? Most of the time, the actual scene is shot in a studio anyway, right? Well, yes, but the establishing shots are there to set the scene for the story.

In photography, you don't get the luxury of establishing shots. But that's okay; you have a whole frame to play with. Use it. Tell the story. Add as much context as you need.

You don't need to see the subject's face, or even get the background in focus, to tell a story. There is enough detail here to tell what's going on, and the lack of directness draws you in.

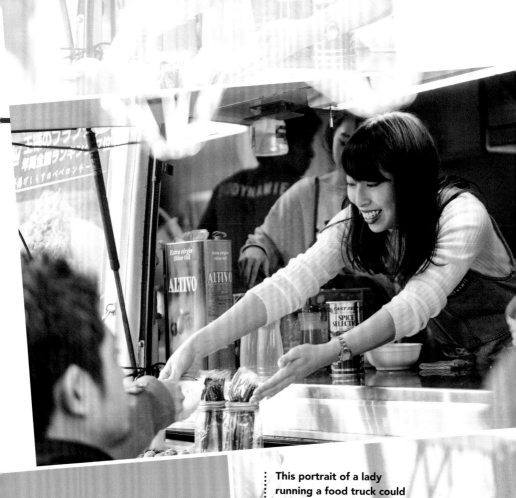

This portrait of a lady running a food truck could have been her posing next to the truck, or her in a kitchen. By instead taking a documentary-style photo of her serving a customer, you're right in the thick of the action. Context does more to tell the story than a photo of just her ever could.

VINTAGE STYLE

Good storytelling in photography is all about evoking an emotion or a feeling. There are many ways of doing that, but one way you can cheat is to take the viewer back to another point in history. Try taking a still life in black and white, and it'll immediately draw the eye.

The trick is to complete the image, though. A black-and-white photo of a mobile phone won't look vintage for another 50 years or so. Sit on an old park bench wearing old-fashioned clothes for that selfie. Check out some real photos from the era you're looking to copy to get some styling ideas, or dive into your grandma's basement to dig out an old sewing machine or even some old photography gear. Include it in the photos. You'll be amazed how quickly you can make yourself or your friends look as if they stepped out of a bygone era!

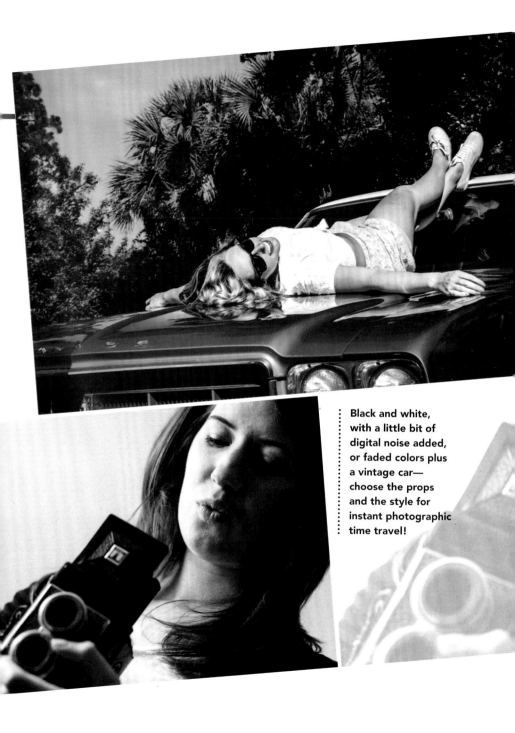

Black and white,
with a little bit of
digital noise added,
or faded colors plus
a vintage car—
choose the props
and the style for
instant photographic
time travel!

13 ⋮ URBAN DECAY

I'm a huge fan of urban decay photos, not least because it is a lovely contrast to how we normally see the cities and towns around us. Watching a building crumble is not only a reminder of our own mortality, but it's also a chance to capture textures and colors more varied and interesting than clean modern buildings. Old buildings have their own stories to tell, and when used as backdrops, they also add a layer of narrative to your photos of people.

Capturing the mystique of urban decay is not hard, but it takes a bit of research and legwork. Seek out rust, crumbling stonework, or buildings that have long been empty. Remember that here, like in all other photography, it's about getting your audience to feel something. Think about what the story is that you're trying to tell before you press the shutter button; it'll go a long way toward portraying your subject just so.

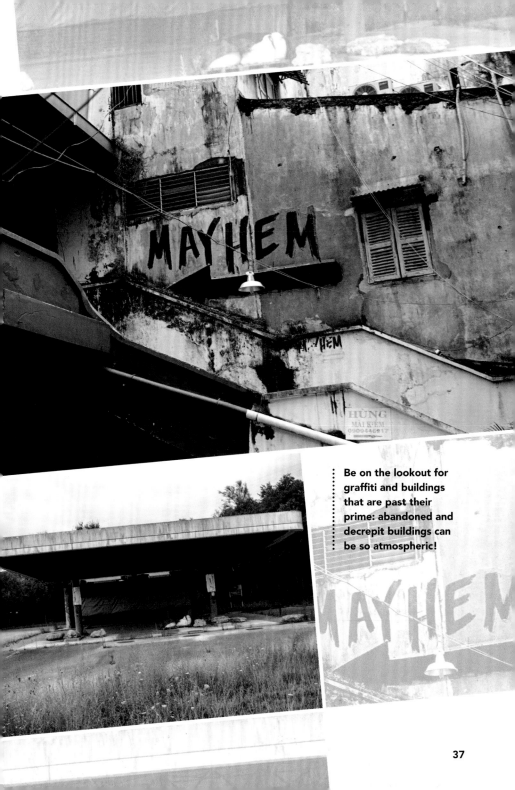

Be on the lookout for graffiti and buildings that are past their prime: abandoned and decrepit buildings can be so atmospheric!

FOCUS ON YOUR SUBJECT

When trying to tell a story with photographs, you have a number of tools at your disposal. Lighting can lead your audience's eye. So can leading lines (natural lines in the image that point to your subject), and other tricks of the trade. The most important one, however, is focus.

Your photograph will probably hinge around a specific element. Perhaps it's a wineglass, a person, or an architectural detail. Whatever it is, it's crucial that the subject of your story is in crisp focus. Check and double check; it happens to all of us from time to time, but it is so disappointing to later discover that your story is losing its impact because the subject isn't quite in focus.

As a bonus, being conscious about what you're focusing on reminds you that you're framing and telling the story around the person or object(s) in your shot, and helps you to better compose and arrange everything else around it.

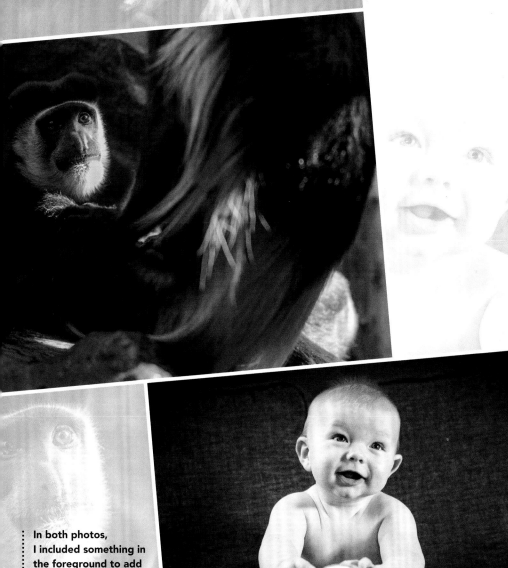

In both photos, I included something in the foreground to add depth to the photo; but my subjects are still in crisp focus. The foreground objects are there to help lead the eye to what I wanted you to look at.

15 CREATE A TRIPTYCH

So far, I've emphasized how important it is to tell a full story in a single frame. But, of course, our walls are big enough to house more than one photo. You'll be unsurprised to learn, then, that it's possible to have several photos telling parts of the same story. Creating a diptych (two photos) or a triptych (three photos) is a little bit like cheating, but it's also tremendous fun.

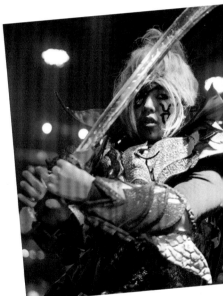

The idea of a triptych is to add more aspects to a photo than you could in a single frame, so make it count. You can choose to show the passage of time, for example, by taking a picture of a live chicken, a raw chicken, then a cooked chicken. Or you could tell a different story about chickens by showing the same chicken in three different environs. Or perhaps three different chickens all singing in the same karaoke room. Get creative—three times as creative as when you're taking just one photo, in fact!

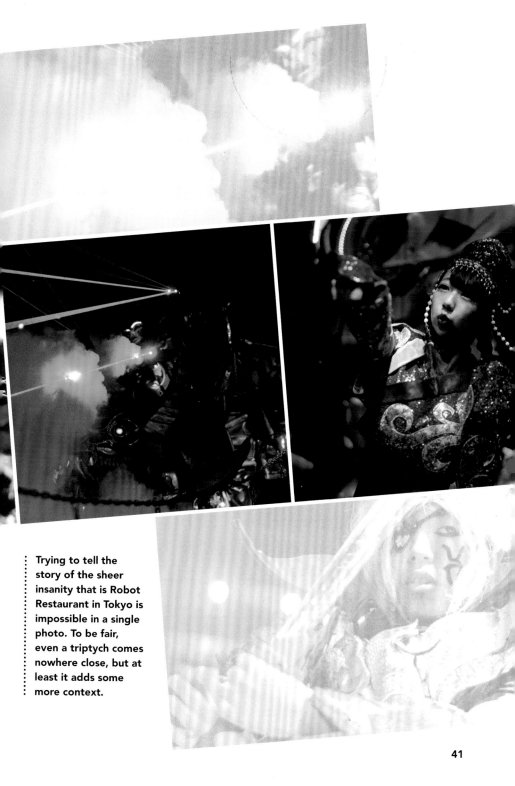

Trying to tell the story of the sheer insanity that is Robot Restaurant in Tokyo is impossible in a single photo. To be fair, even a triptych comes nowhere close, but at least it adds some more context.

16 STEP ASIDE *NAT GEO*—IT'S STORYTELLING TIME!

Taking it a step further from just a diptych or triptych, don't hesitate to use more frames to tell a more in-depth story. *National Geographic* is the king of this, commissioning elaborate photographic essays, telling the story of cultures, animals, or locations (sometimes all three) in extended form.

Pick up a copy of *National Geographic* to get inspired and choose a topic that you can explore in depth. It could be anything. Myself, I have taken hundreds and hundreds of photos of the locks on the insides of bathroom doors all over the world. Sure, it ain't exactly highbrow, but it has been a fun and unique project that I've exhibited several times.

By all means, please do try to come up with a better idea for your photo essays than locks on bathroom stalls. But, whatever you choose, the indulgence of exploring a photographic subject in depth is fantastic.

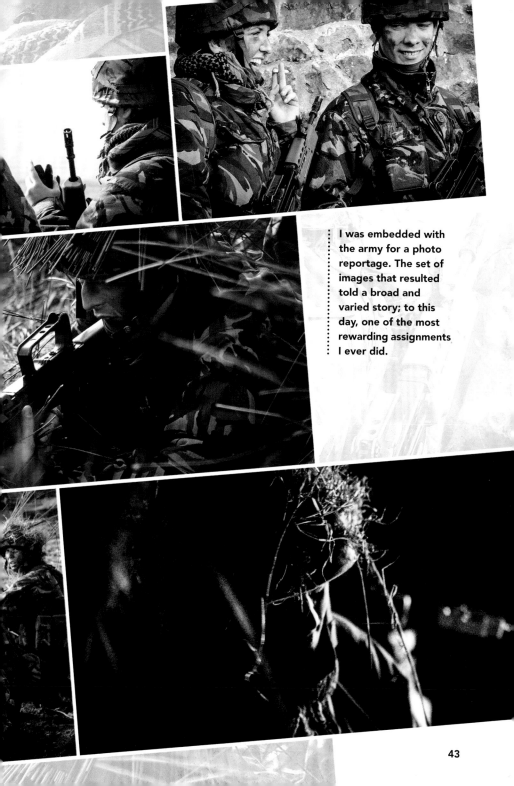

I was embedded with the army for a photo reportage. The set of images that resulted told a broad and varied story; to this day, one of the most rewarding assignments I ever did.

17 WHO IS THE PHOTO FOR?

When we're telling stories in person, we adjust the language we use automatically. The way you tell a story to your cat (I won't judge...) differs from how you would tell the same story to your kids, to the builders who are working on your house, or to the police officer who comes to take a statement about why, exactly, you kidnapped a chicken for a photo shoot.

The point I'm trying to make is that when you're telling stories photographically, it is easy to get so caught up in the medium and the subject, that you forget about your audience. Don't fall into that trap. Ultimately, your audience will make up their own minds, but if you're able to use symbolism and compositional tricks to evoke emotions appropriate to your target audience, there's a much better chance that your story will be well received. Thinking about what story you're telling, how you're telling it, and—crucially—who you are telling it to, is a great way to get ready for a shoot.

This early-morning London scene could be used in lots of different contexts; I shot it for a travel blog to illustrate that walking is the best way to get around the city. To tell the story for this particular audience (tourists), I wanted to show pedestrians and some landmarks that were recognizable but not totally cliché. (In this case, I chose the Shard and the Millennium Bridge.)

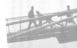

TELL A STORY

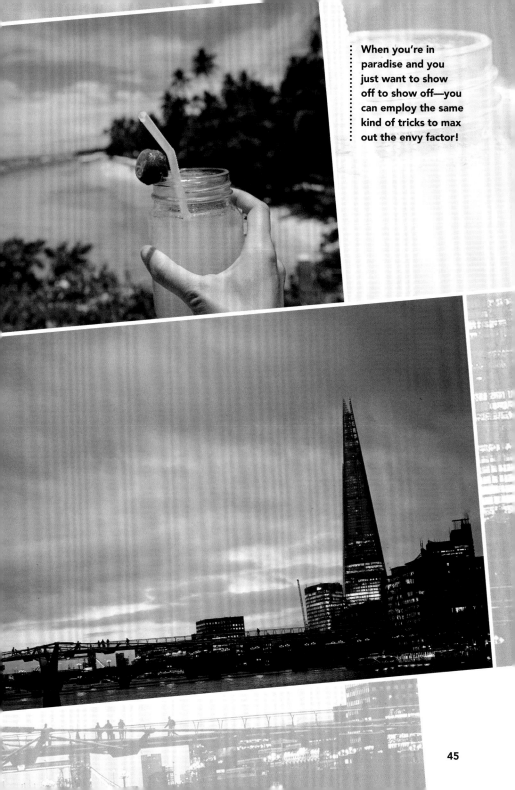

When you're in paradise and you just want to show off to show off—you can employ the same kind of tricks to max out the envy factor!

18 THINK BEFORE YOU SHOOT

I'm often guilty of just wandering around aimlessly with my camera, and snapping the odd picture here and there. That works when you're just shooting casually, but if you're on a mission to tell a specific story, planning really does go a long way.

By planning, I don't necessarily mean scripting out every shot you mean to take, but do think about some of the core parts of the story you're planning to tell and the equipment you'll need to tell that story.

Try something like, "At the end of this day of shooting, I am hoping to have taken photos A, B, and C to help tell the story of X. To accomplish that, I need my smartphone and a baseball cap with some cat ears on it." Do a bit of research to learn more about the location, your subjects, or other similar photos that have been taken. It isn't much, and it's even kind of fun, but you'll be amazed how many photographers don't even spend that much time thinking about an upcoming shoot. It makes a huge difference.

In live music photography especially, it's a huge advantage if you've seen the venue ahead of time. How close you can get to the stage and what kind of lighting is in use, for example, have a huge impact on the equipment you'll have to bring, where you'll need to stand, and the shots you'll be able to get.

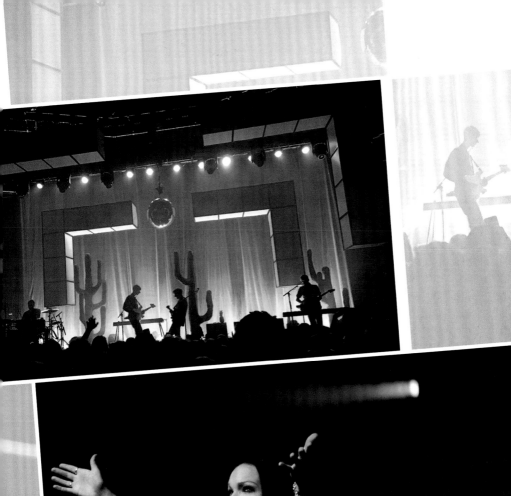

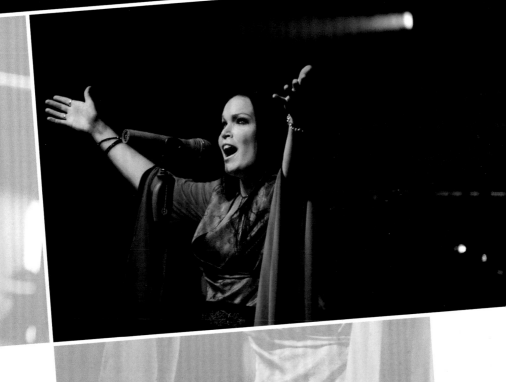

LEARN TO GIVE GREAT DIRECTION

Sometimes the perfect shot falls right into your lap, or a particular scene just catches your eye. But if you've got a specific idea in mind, you're probably going to have to learn to speak up. It's just the same as arranging inanimate objects for the most pleasing still life, or the food on your plate for the most appetizing composition. Getting good at directing is hard and takes a long time, but I do have a pro-tip: show, don't tell. Whenever you want a model to do something, don't just say "bit to the left," or, "stand on your tip-toes and stare towards the stuffed teddy bear," or, "grin like a toddler on LSD." Actually act out what you want them to do. It feels weird but works great!

The other thing you can do to direct exactly where you want your model to look is to first direct their head, then their eyes. "Look straight forward and move only your head to follow my hand." Once their head is aiming the way you want, follow up with, "Okay, perfect. Now with just your eyes, follow my hand," and move their eyes to where you want them.

Even professional models can find it hard to read your mind and come up with the pose you want by themselves. This is when you need to help them out, to show what you're after.

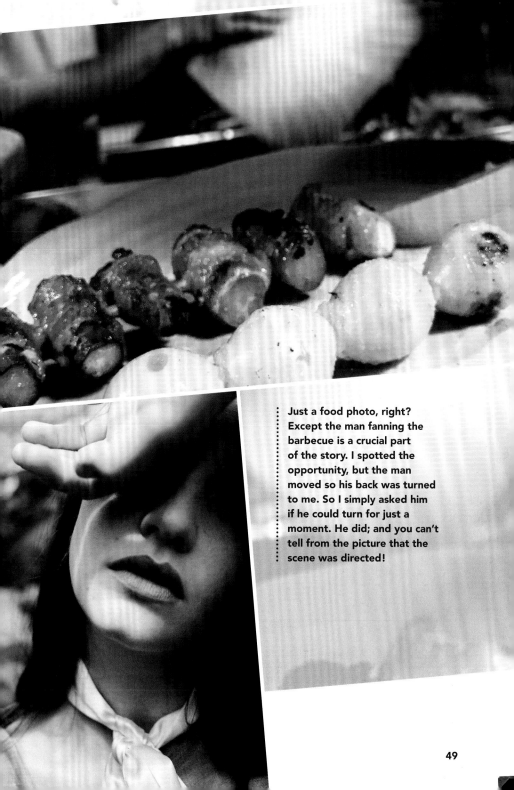

Just a food photo, right? Except the man fanning the barbecue is a crucial part of the story. I spotted the opportunity, but the man moved so his back was turned to me. So I simply asked him if he could turn for just a moment. He did; and you can't tell from the picture that the scene was directed!

LEARN THE BASICS

This is a book of photography tips, so I won't get too deep into the weeds talking about hyperfocal distances, prime lenses, and the advantages of second curtain flash. Instead, we're going to have lots of fun with the basics. If you want to raise your photography game, there a few simple tricks to employ and a few things to keep in mind that will stop you from making silly mistakes and take your shots to the next level.

I'll smuggle in a few tips here and there that'll teach you some techy stuff—all sneaky-like. But first and foremost, it's about enjoying photography!

20 ILLUSTRATE MOTION WITH LONG EXPOSURE

A lot of great photography books (and some of the ones I've written) explain in detail how shutter speed works. Very briefly: a long shutter speed illustrates motion. A short shutter speed freezes motion. There are a couple of additional things to keep in mind, but at the heart of it, that's all you need to know.

So—let's experiment! For this one, you need a camera with manual settings and a tripod. Stick the camera on the tripod and find an overpass somewhere with a lot of busy car traffic rushing by below. Select shutter priority exposure mode, set ISO to 100, and choose a 1-second shutter speed for starters. Press the shutter button. It's likely that your exposure will be off—it's a tricky lighting situation. Use the EV compensation on your camera to adjust up or down until the brightness in the photos looks right. You should end up with a photo where the car lights appear as light streaks on your image. Cool, eh? Experiment from there to perfect the technique—it's easy, but it looks like magic!

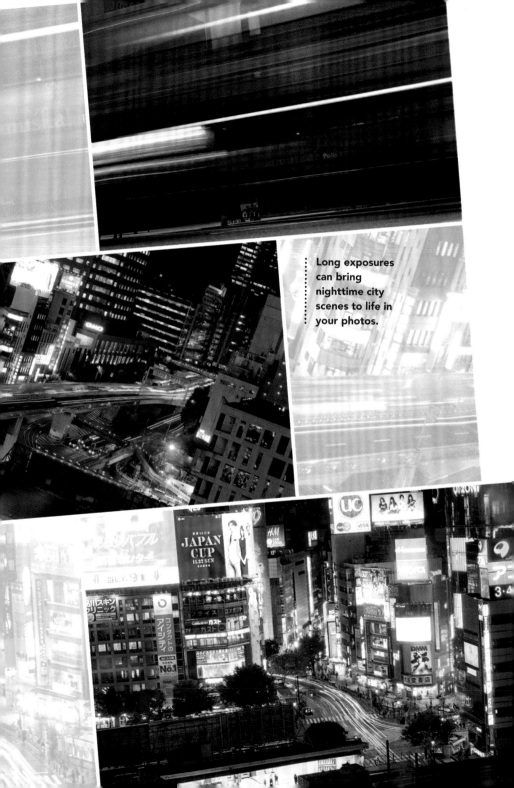

Long exposures can bring nighttime city scenes to life in your photos.

FRAME YOUR SUBJECT

I've already talked about how context is everything, but remember that you can do more than add context—you can also use the environment around your subjects to frame them. Shooting a portrait through trees, a window frame, or an arch or doorway makes a really cool natural frame. It leads the viewer's eye to where you want them to look and is a great way to add some visual interest to the photo.

When using this tip, be very careful to double-check your focus. It's easy to take a photo of a person through foliage, for example, only to later realize that the plants are in focus rather than the subject. I mean, if I'm your model, that's probably a good thing, but for most portraits, you'll want to get it right.

To illustrate, see these two photos of the same mountain, taken seconds apart. They tell completely different stories! Throughout this book, be on the lookout for framing—I use it more often than you'd think.

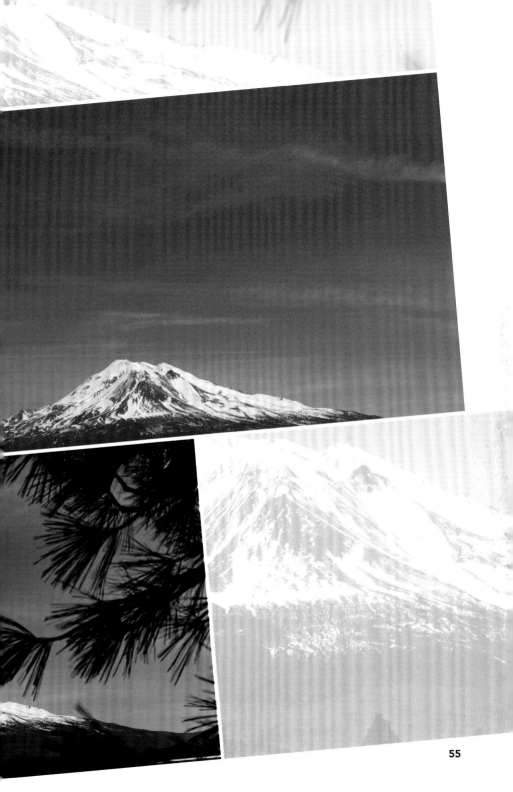

22 ABC: ALWAYS. BE. CAPTURING.

I've started many 365 projects, but to my shame, I've never finished one. That's why they make me write books, I suppose, I'm a better writer than photographer. But don't let that stop you; the rule is still true. Always be capturing!

Forcing yourself to take photos all the time helps you keep your eyes open to the possibilities for interesting photography in the everyday world. Keeping your photographic senses keenly tuned and your shutter finger well practiced is the hallmark of a good photographer. Decide to take at least one photo every day, no matter what, and I guarantee that keeping it up will make you a better photographer.

In fact, put the book down right now, look around the space you're in, and take a photo. I dare you.

The world is full of beauty, and training yourself to always be on the lookout for it is a great way to ensure you're getting a little bit better every day.

ISO & SHOOTING IN LOW LIGHT

Most mobile phones these days have a fixed aperture (lens opening), which means the phone uses shutter speed and ISO to regulate its exposures. (ISO is the camera sensor or film's sensitivity to light.) For bigger cameras, you probably have a variable aperture, which is great when there's a lot of light, but for low light, you'll soon run into the need for a higher ISO.

The main thing you need to be aware of is that with high ISOs, you'll get more digital noise. It's unavoidable, but on many cameras, the digital noise can actually look pretty cool. The first thing that goes is the color rendition, but you can convert your photos to black and white easily enough, which means that the digital noise just looks like film grain. Classy and retro all at once!

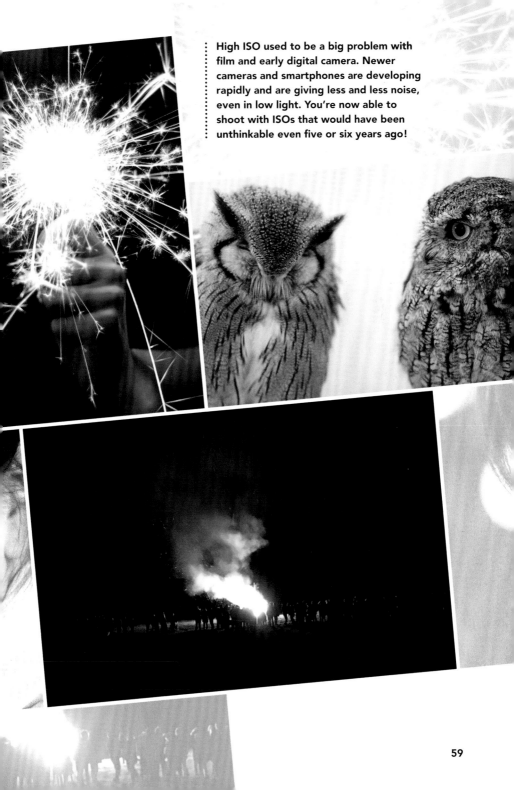

High ISO used to be a big problem with film and early digital camera. Newer cameras and smartphones are developing rapidly and are giving less and less noise, even in low light. You're now able to shoot with ISOs that would have been unthinkable even five or six years ago!

24 | WORK WITH MODELS

Your long-suffering friends and family will be delighted when you start working with models in your photographic work; it gives them a break from being in front of your camera all the time. Sound expensive? Well, if you try to hire Kendall Jenner it probably is, but it doesn't have to be.

There are a lot of models out there who are just starting out and are happy to work with photographers on a TFP (time-for-prints) basis, which is realistically a catch-all for "will work in exchange for photos to use in my portfolio." Most models are happy to accept files by e-mail or on a USB thumb drive once they've been edited.

Working with people you don't know well is different from taking photos of your friends, and I highly recommend trying it out. It's fun, and learning to direct models may be an important skill along your photographic journey.

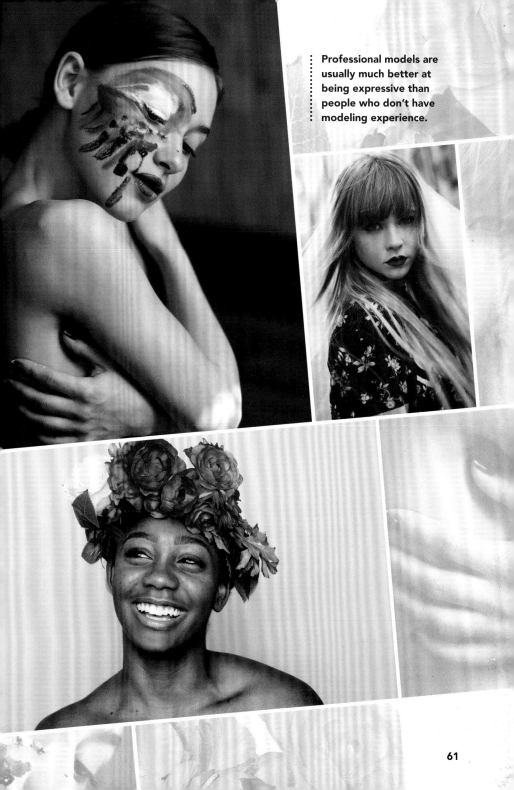

Professional models are usually much better at being expressive than people who don't have modeling experience.

61

25 FIRST COPY, THEN CREATE

I've already mentioned photographic clichés, but I want to revisit the idea of copying other photographs. Emulating someone else's work can feel a bit iffy, but call it an homage if it makes you feel better.

Look at Flickr's Explore page—it's a collection of the day's best photos posted to Flickr, as determined by Some Mysterious Algorithm. Pick one of the photos, analyze it, and try to recreate it yourself. Then put them side-by-side and see what you did better than the original photo and where you can improve.

Copying someone else's photos is bloody hard, and it can be frustrating at first, because if you've created a perfect copy, you still haven't added anything new to the world of photography. Don't let that stop you: I'm a strong believer in using this as a learning tool. Along the way, your creativity will kick in, and you'll be making original works before you know it.

I first saw this photo effect on a movie poster many years ago. It took me an embarrassing number of tries to finally copy it successfully, but I learned a lot in the process.

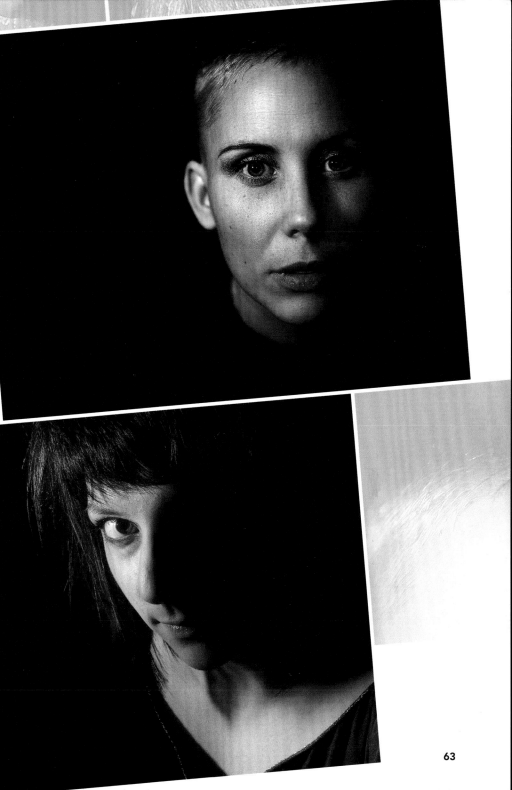

26 CLOUDS ARE YOUR FRIENDS

If you're planning a day on the beach, clouds are your sworn enemy. As a photographer, however, embrace them! They're incredibly useful for creating gorgeous, soft light. The problem with the sun is that while the giant ball of fire in the sky is nice and bright, direct sunlight tends to create harsh shadows, and it's hard to make photos look good under those circumstances.

Studio photographers spend thousands on accessories that help create beautifully soft light, but the clouds do exactly the same thing, completely free of charge. Grab a friend and head outside to shoot some photos the next time the sky looks gloomy. Trust me; it'll make their skin look fantastic, and the quality of the light will be downright lush.

There's really nothing else you need to do, either, your camera will compensate for the reduction in light. Just head outside, and enjoy using the best light you'll ever find for your photos!

LEARN THE BASICS

These two photos were taken on the same day. It's almost impossible to get a photo taken in direct sunlight to look good. People squint, and the shadows on their face can be unflattering. In the top photo, I cheated a little bit and used a reflector to bounce some of the sunlight back. In the bottom shot, we were in a gondola halfway up a mountain, in thick fog. The light was spectacularly better as a result.

TRY HARD LIGHT FOR DRAMATIC PHOTOS

On the previous page, I was getting all excited about the soft light clouds give you. As you might expect, the opposite is also possible. Hard light is a thing. When used properly, you can create fantastically dramatic photos. Street lights, a table lamp, or direct sunlight can be used to get hard lighting. It's a challenge to get an attractive photo, but there are subjects that look good with sharp lighting.

Geometric objects (such as some buildings) can look especially good in harsh lighting. People, too, can be photographed with hard light, if you incorporate the unusual light into the story you're trying to tell. Theaters, especially, use spotlights (which are extremely hard light sources by definition) to great effect to help tell part of the story, so the next time you're in a theatre, pay attention to how the lighting designers use light to help discern good from evil and playful from serious. It isn't easy, but when done well, can be a beautiful tool!

Harsh side-lighting can be difficult to pull off; it shows off every blemish on the skin. But when it looks good, it looks great!

28 KEEP YOUR BACKGROUNDS CLEAN

When photographing people, the number one mistake is not considering the background. Of course, the main focus of the photo will be your subject, but if the background is messy or irrelevant to the subject, it becomes a distraction.

The best backgrounds are either plain-colored or simply patterned, or out of focus. The other option, of course, is to ensure that the background tells part of the story. Taking a photo of a chef in front of an industrial kitchen or a mountain climber halfway up a mountain works great.

The most important thing is to pay attention to what's going on behind your subject. You don't want a lamp post sticking out of your model's head, for example.

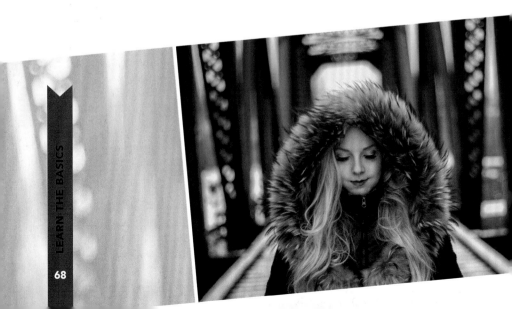

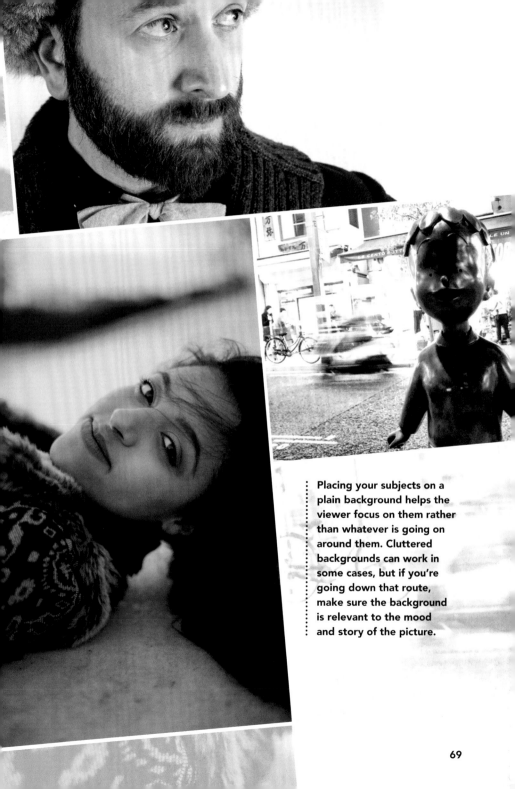

Placing your subjects on a plain background helps the viewer focus on them rather than whatever is going on around them. Cluttered backgrounds can work in some cases, but if you're going down that route, make sure the background is relevant to the mood and story of the picture.

69

29 GET CLOSE TO CREATE BEAUTIFUL DEPTH OF FIELD

"Depth of field" is a term you'll hear bandied about a lot, often incorrectly. What people are usually talking about is a shallow depth of field, when the foreground is in focus and the background has a beautiful, blurry quality to it.

You can replicate this effect on a smartphone, but you do have to know a little bit about how it works. Most smartphones have a pretty small aperture, which automatically limits your ability to throw the background out of focus. The way to accomplish this on a smartphone camera is to get really close to your subject. So, for this effect to work, you probably need to photograph something smaller than a human being—or at least get really close, perhaps unflatteringly so, to a person.

But for the purposes of shallow depth of field, the closer you can get, the better. Up to a point, that is. Get too close, and your camera will no longer be able to focus, and you lose the effect. Experimentation is the key here, as the qualities of the camera will differ from phone to phone.

LEARN THE BASICS

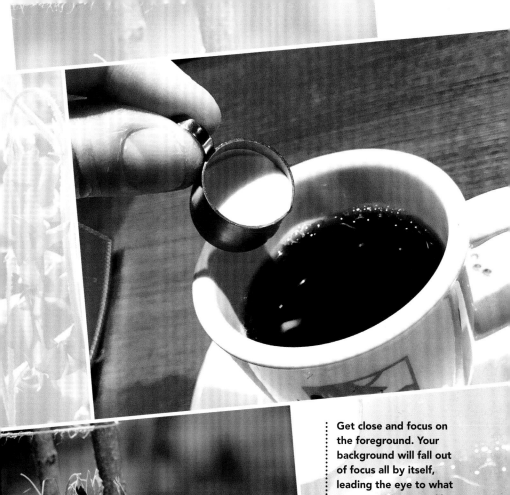

Get close and focus on the foreground. Your background will fall out of focus all by itself, leading the eye to what you want it to see—like the ridiculously small cream dispenser in the photo above.

30 JUST KEEP SHOOTING!

The dirty little secret of accomplished photographers is that they don't take great photos all the time. That's impossible.

Truly great photographers have a higher good-to-bad ratio than the rest of us. They might have one great photo for every fifty they take. But even if your ratio is worse, you can still take a lot of great photos, by taking photos all the time. Think about it: With a combination of skill, luck, and a bit of experimentation, you may be able to take one great photo for every five hundred you take. So, how do you take ten amazing photos? Simple, take 5000 photos.

It sounds like a crude approach, but trust me, it works!

Take photos. All the time. Never stop. The great photos will come, and your great-to-rubbish ratio will slowly start improving.

LEARN THE BASICS

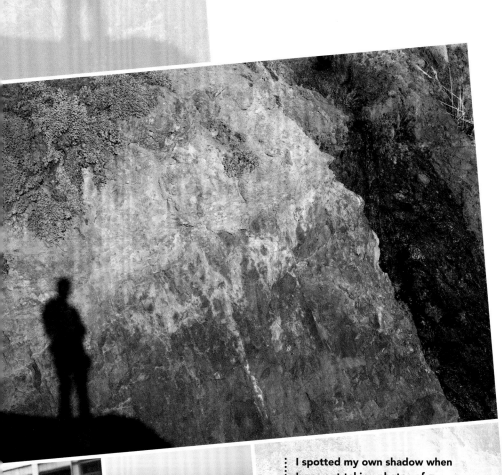

I spotted my own shadow when I was out taking photos of a sunset. I figured it would make for an interesting self-portrait of sorts; but once again, I'm not completely sure it works. It has interesting textures, but I'm not recognizable as a person (or as a photographer), and given that I don't really know what sort of a story I'm telling, I guess the photo might be a failure. But that won't stop me from experimenting in the future!

31 DIFFERENT TYPES OF BLUR & HOW TO FIX THEM

Blur is the enemy of good photos, but it can be tricky to figure out the cause. There are three main types of blur, and knowing which one you're dealing with is the first step to solving the problem.

1. Focus blur. This happens when your subject isn't in focus. This one's down to you—make sure your subject is in focus before you press the button!

2. Camera shake. If the camera moves, even slightly, while you take a photo, it's going to cause blur. You can avoid this blur by using a faster shutter speed or holding the camera still (steady your arms on a wall or a tree, or use a tripod).

3. Subject blur. This is when you have a shutter speed that is too slow to freeze the movement of your subject. Sometimes the blur of a subject moving across the frame is exactly what you want; but otherwise, make sure your subject doesn't move, or use a faster shutter speed.

In this photo, I decided to change the camera's position from portrait to landscape orientation, and I accidentally took a photo while I was moving it. The result looks pretty cool, but this is a classic example of camera shake blur.

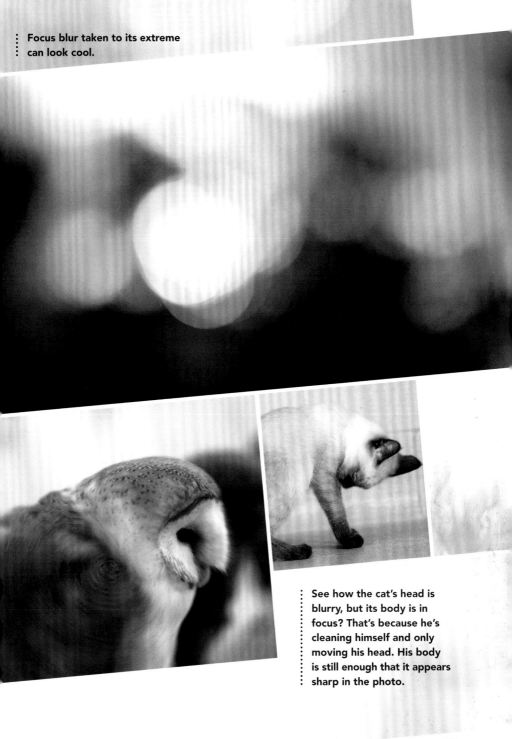

Focus blur taken to its extreme can look cool.

See how the cat's head is blurry, but its body is in focus? That's because he's cleaning himself and only moving his head. His body is still enough that it appears sharp in the photo.

ARGH! OUT OF FOCUS! AGAIN!

In the previous tip, I talked about focus blur. Getting your subject in focus is sometimes easier said than done. One challenge in this area has to do with minimum focus distance. If your subject is closer to your camera than the lens's minimum focus distance, it can never be in focus.

Look up that distance in the manual of your lens or camera, and learn to estimate it. Better still, experiment to see what distance you can focus down to reliably, and keep your subject farther away than that limit.

On mobile phones, you can usually tap a subject on the screen to make your camera focus where you want it to. Make sure you don't move the camera after that.

Making sure the camera doesn't move takes some getting used to, but try putting your phone on a tripod while you get the hang of it. Once you get a feel for it, try the same technique handheld.

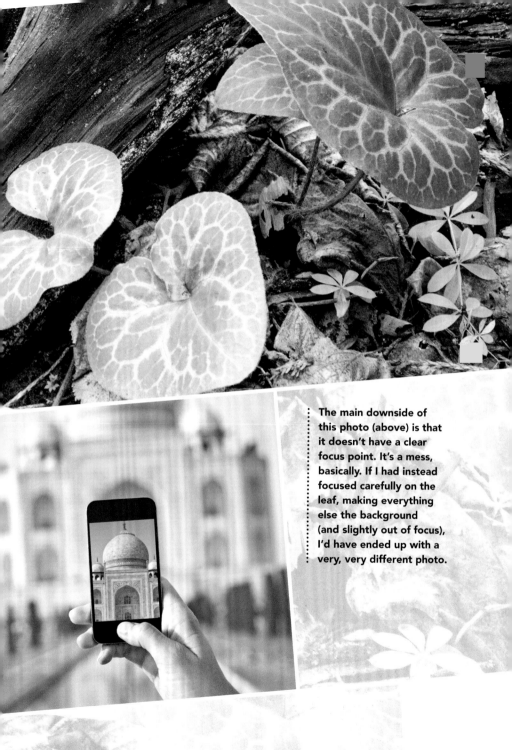

The main downside of this photo (above) is that it doesn't have a clear focus point. It's a mess, basically. If I had instead focused carefully on the leaf, making everything else the background (and slightly out of focus), I'd have ended up with a very, very different photo.

33

CAN I RESCUE MY
PHOTO IN PHOTOSHOP?

There are some issues that you can fix in post-production, but in general, try to make that your absolute last resort. Re-shooting a photo that didn't come out great is usually much, much faster than, "Ah, I'll fix it in post."

It's also often excruciatingly hard to fix lighting and color mistakes after the fact. Try to train yourself to review images on the scene as you take them. If there's anything about them you don't quite like, fix it on the spot and re-shoot the photo.

Nothing is as frustrating as getting home and realizing that one of your favorite shots is just a tiny bit out of focus. I know; it used to happen to me all the time. These days, I'm incredibly boring: I'll zoom in and carefully inspect every photo I take. It slows down the photo-taking process, of course, but it has saved my bacon more than once.

LEARN THE BASICS

I really wished I had brought a reflector with me into this Sequoia forest. There were some amazing shapes and textures to capture, but the light didn't quite work out. I spent hours trying to rescue this photo in Photoshop. In fact, this image was the inspiration for this tip—if I had brought the right equipment and captured the photo the right way in the first place, it would have taken seconds to edit it into shape.

34 | BEING A PRO PHOTOGRAPHER IS REALLY BLOODY HARD

If you're considering becoming a professional photographer—don't, unless you have skills or knowledge beyond photography to add to the mix. Being a photographer is a business like any other, and as SLR cameras have dropped in price, competition is absolutely brutal.

Let's be honest though, if your dream is to become a pro photographer, you'll probably ignore my advice not to, as you should. In that case, try to at least put together a proper business plan and get someone who has business experience to go through it with you. Pay extra attention to what your customer segment will be, and how you're going to market your services to those people; in my experience, that's where a lot of fledgling photography businesses fall apart.

The other stumbling block is financials: it's very tempting to charge too little for your services. Don't. If you identify who your clientele is and target them properly, you'll have found a customer who is willing to pay a premium for your services. You'll need to make a living, after all.

LEARN THE BASICS

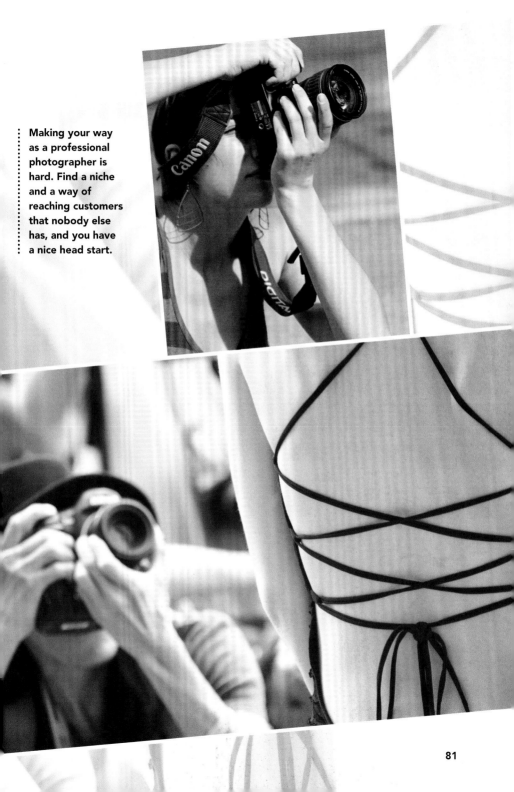

Making your way as a professional photographer is hard. Find a niche and a way of reaching customers that nobody else has, and you have a nice head start.

PART FOUR

KNOW YOUR
EQUIPMENT

If you're reading a book like this, you probably have already made a choice about the camera you love to use—but are you getting the best out of it? Whatever kind of camera you have —whether it's a dedicated DSLR or your smartphone camera— it will come with certain advantages and drawbacks. You need to know the limitations of your equipment, but equally important is to know what extra tools are available, and how to use them to achieve what your camera, on its own, can't.

35 | ALWAYS CARRY A TRIPOD

I've lost count of how many shots I kept missing carrying a tripod with me all the time. Not a full a small mini-tripod just strong enough to suppor or phone. When the sun sets, a tripod is a must-have for good photos in low light.

In some circumstances, you can improvise, but if you want to experiment with time-lapse photography especially, you're going to need some way of keeping your camera securely in place. These days, I never leave the house without a Pocket Tripod in my wallet. It's a credit-card-sized piece of plastic origami that turns into a stand for your phone. Perfect for time lapses, long exposures, watching movies on my phone, or the odd Skype conference call. It comes in handy surprisingly often, and takes up barely any space. Seriously, carry one around with you!

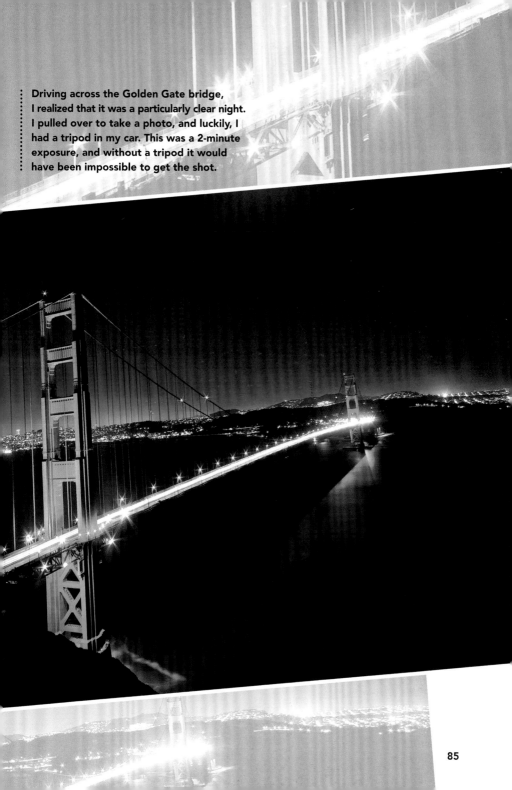

Driving across the Golden Gate bridge, I realized that it was a particularly clear night. I pulled over to take a photo, and luckily, I had a tripod in my car. This was a 2-minute exposure, and without a tripod it would have been impossible to get the shot.

36 SOFTEN THE LIGHT FOR MORE FLATTERING IMAGES

As a general rule, the bigger a light source is, the softer the light. Before you send me a smarty-pants email—yes, the sun is huge. But it's far away, so it represents just a tiny dot in the sky, which is why it creates harsh light. This is the reason why studio photographers will use umbrellas or softboxes on their lights: by increasing the size of the light, they get softer, prettier light that makes portraits lovely and soft-looking.

Softboxes are expensive, though. Light is light, and there's no reason to get fancy—it's possible to soften light by simple, inexpensive means. Placing a bed sheet between the light source and your model, for example, reduces the amount of light, sure, but it increases the softness significantly. Alternatively, try bouncing the light off a white wall or ceiling to soften it.

KNOW YOUR EQUIPMENT

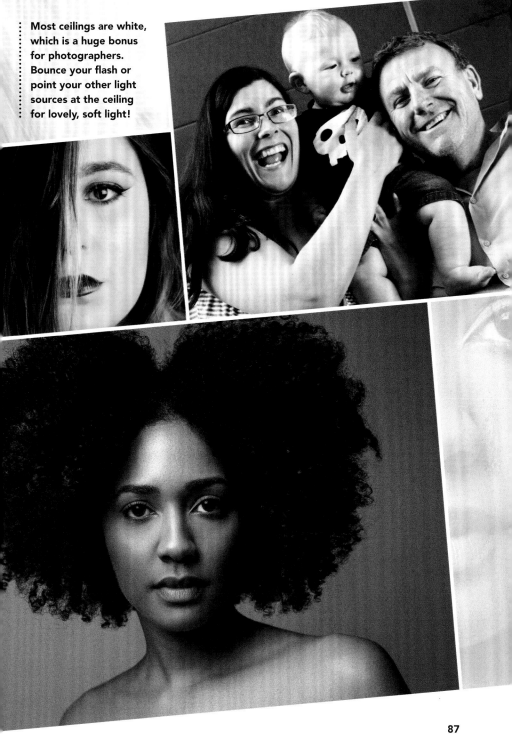

Most ceilings are white, which is a huge bonus for photographers. Bounce your flash or point your other light sources at the ceiling for lovely, soft light!

37 TRY DIFFERENT FOCAL LENGTHS

If you take most of your photos with a mobile phone, it's worth being aware that most cell phones have a fixed wide-angle lens. Most of the time, that's what you want, but for people, the case might be slightly different. Using a wide-angle lens on a face distorts your model's facial features quite a bit. It's generally accepted that shooting with a longer lens more flattering to your models.

If you shoot with a compact camera or an SLR, aim for a 100mm focal length or so (as opposed to the 20–28 equivalent you usually find on mobile phones). On a mobile, try taking a step back and then cropping the photo, or use an accessory telephoto lens to take your portraits. If you're one of the lucky owners of the newest generation of iPhones that have two lenses, use the tele lens for your people photos—just trust me on this one!

Shooting with a wide-angle lens (as in the color photo) gives people's faces completely different proportions. Compare this photo with the black and white shot of the same model (my ever-patient wife); her face looks significantly different, mostly because the photo was taken with an 85mm lens.

KNOW YOUR EQUIPMENT

38 | DON'T USE THE FLASH

Whether you do most of your shooting with an SLR or a smartphone, turn off your flash. I know, it sounds like a weird tip, but with very few exceptions, photos taken with the built-in flash on a camera look terrible, to the point that you may as well not bother.

If the scene you're trying to photograph is so dark that you need a flash, find a way to either hold the camera super-still (using a tripod or balancing your camera on a wall works well), or add more light to the scene by other means.

One top tip here: If you have friends nearby, ask them to light up the scene with their phone flashlights. The quality of the light looks way, way better when the light source isn't right next to the camera lens.

If you have a newer mirrorless camera, you can push even further. The portrait (right) is taken at ISO 6400 by streetlight, and the photo of the statue was taken at a whopping ISO 12,800!

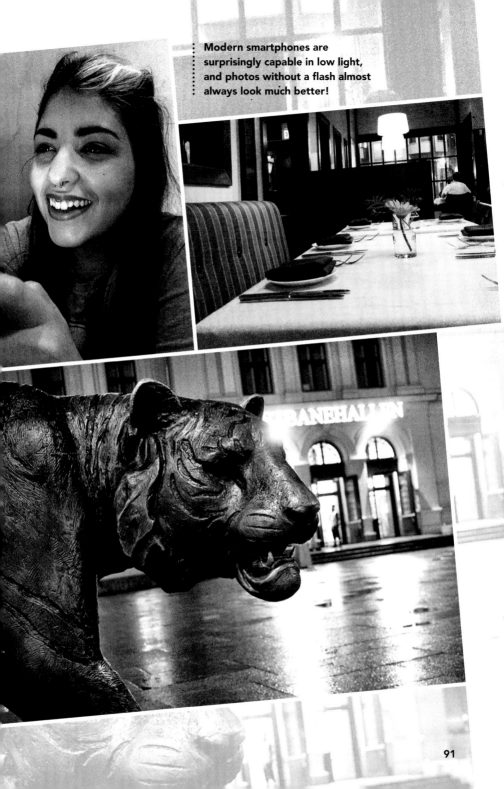

Modern smartphones are surprisingly capable in low light, and photos without a flash almost always look much better!

91

39 SHOOTING WITH EXTERNAL STROBES

External flashes are far, far better today than they were a decade ago. Not because the flashes themselves have got that much better—they haven't really—but because cameras are becoming more lenient to shooting at high ISOs.

Higher ISO means higher sensitivity. That means that your portable strobes don't have to put out as much light in order to capture a photo. As a result, they recycle (i.e., get ready for the next shot) much faster, and can be used in situations that were unthinkable even
a few years ago.

Don't worry about buying expensive camera-brand strobes, either; you can get cheap versions for a fraction of the price. They won't last as long, but you can replace them four or five times before the price gets anywhere near a big-name strobe. In the meantime, you can practice your techniques and get some fantastic photography action going!

When learning to use external flashes, a stuffed animal or, as in this case, a very patient kitten, makes a great subject to practice on. Shooting a static scene is another fun way to explore the effects of strobes.

40 EXPLORE STROBIST PHOTOGRAPHY

Since external flashes improved vastly in quality, it was no longer necessary to use huge, heavy studio flashes to take good, studio-quality photos. A few creative souls started using battery-powered off-camera strobes with light modifiers to start doing high-end event, wedding, and portrait photography. The new techniques became known as the Strobist movement (coined by David Hobby, who spearheaded it).

A full guide on how to do Strobist-style photography is a bit much for a simple tip, but I just want to leave the idea with you. You can buy a set of three or four cheap strobes for a couple hundred dollars that will let you spend weeks of experimenting and following online tutorials. Shooting with external strobes is definitely toward the top end of advanced photography, but your portrait subjects will thank you for it—the difference it makes is truly night and day.

KNOW YOUR EQUIPMENT

With one or two exceptions, all the photos that look like studio shots in this book are actually taken with small off-camera flashes. Try it out yourself!

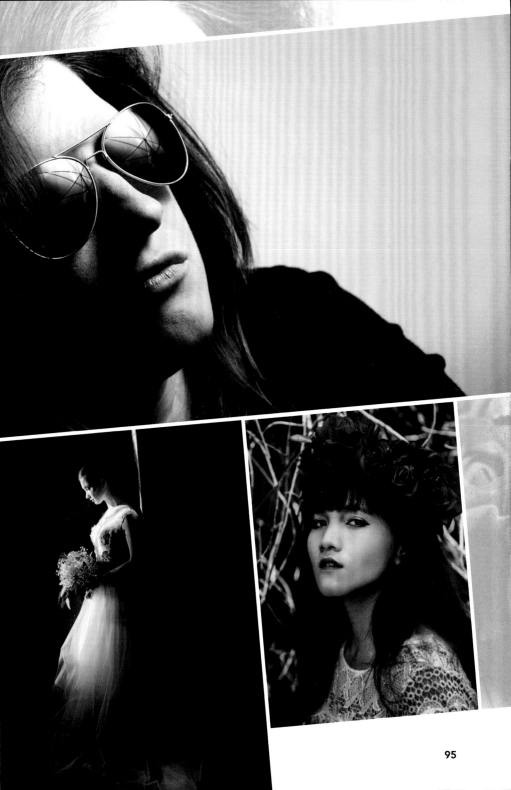

PICKING A GOOD LENS

A lot of novice photographers make the mistake of spending all their money on a camera body and as little as they can on the lens. And then they wonder why their photos don't come out as well as they'd like.

My tip is to save up a little bit longer. Spend 25% of your budget on a camera body, and the remainder on the best lens you can afford. I would recommend buying a great 50mm prime lens. Sure, they aren't as convenient as zoom lenses, but dollar-for-dollar, they are phenomenal value. They tend to be quite good in low light, built like tanks, and able to deliver fantastic-quality photos.

Pro photographers can get really geeky about lenses— they open up a world of possibilities.

KNOW YOUR EQUIPMENT

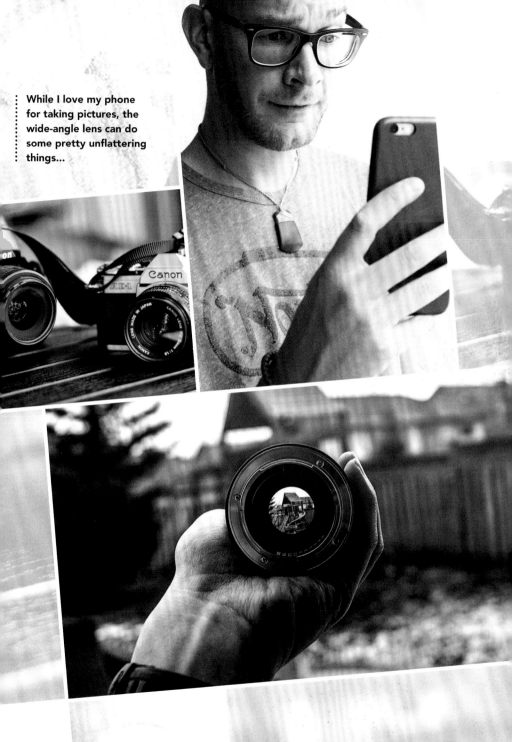

While I love my phone for taking pictures, the wide-angle lens can do some pretty unflattering things...

42 ZOOM WITH YOUR FEET

Photographers love the expression, "zoom with your feet." What they mean is, instead of zooming in using the zoom lens on your phone or camera, just walk closer.

There are many reasons why that's solid advice, but the most important one is, as you zoom in, you start showing off some of the problems in your photographic equipment. Most entry-level zoom lenses are terrible when they are zoomed fully in—if you paid less than $1000 for your zoom lens, that probably applies to your lens, unfortunately. And, the digital zoom you find on mobile phones is completely useless.

Make it a habit to get as close as you can to get the photo; it gets you closer to the action, your photos will look better, and it helps you think more actively about what you're trying to accomplish from a photograph.

Your feet are a far better zoom lens than your zoom lens!

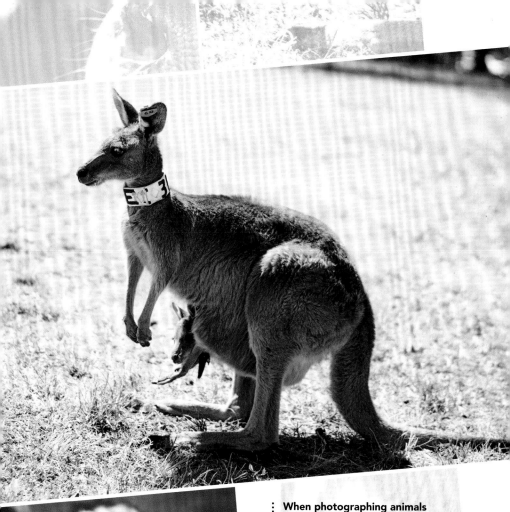

When photographing animals especially, a zoom lens might come in handy; but if you don't have one, it's time to get sneaky. It took me quite a while to creep up to this mama kangaroo (above) with her little joey, but once I got close enough to get a good photo, the images were definitely worth it, and far more intimate than if I had shot from across the meadow. Use common sense, though—be safe!

43 FILM IS BEST!

Most of this book is focused on digital photography.
Why? Simple: digital is significantly better in pretty
much every measurable and unmeasurable way. The
"film is best" mantra of photographers of yesteryear
might have been true a decade ago, but these days,
it's an extraordinarily rare photographer who uses
a fully analog workflow from beginning to end. If at
any time you find yourself scanning the photo to edit
it in Photoshop, you're losing any of the advantage
you may once have had.

If, however, you're saying that film is more fun than
digital, I can't disagree with you. I'm a huge fan of
experimenting with various films—and goofing around
with Polaroids is more fun than you'd think possible. The
instant, tactile gratification (with Polaroids) and playing in the
darkroom (with other film) offer amazing contrasts to how we
usually take photos. For those reasons, I encourage you to go
play. Beg, borrow, or steal a camera, and knock yourself out!

KNOW YOUR EQUIPMENT

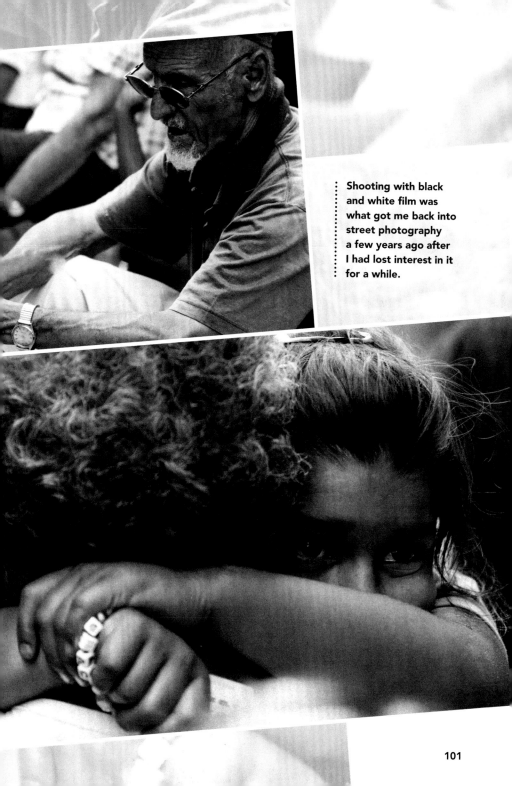

Shooting with black
and white film was
what got me back into
street photography
a few years ago after
I had lost interest in it
for a while.

44 USE BURST MODE TO GET THE PERFECT SHOT

On some smartphone cameras, you can shoot a number of photos in quick succession by holding the shutter button down for a little while. This trick—known as burst mode—is the magic sauce that makes a whole new world of photography possible.

Henri Cartier-Bresson (look him up, he's pretty awesome) often spoke of capturing "the decisive moment." He's talking about that microsecond where everything falls into alignment. The great news is that whether you're shooting portraits, action photos, or, well, pretty much anything else, burst mode is an excellent shortcut to ensure you capture the decisive moment. When cool stuff is happening, just hold the shutter button down, and later review the hundreds of photos you took.

It's fun to scroll back and forth to see what happened, but you'll soon discover that burst mode is a ridiculously powerful tool for photographers. The old photography masters had perfect timing. You have technology, and you know how to use it.

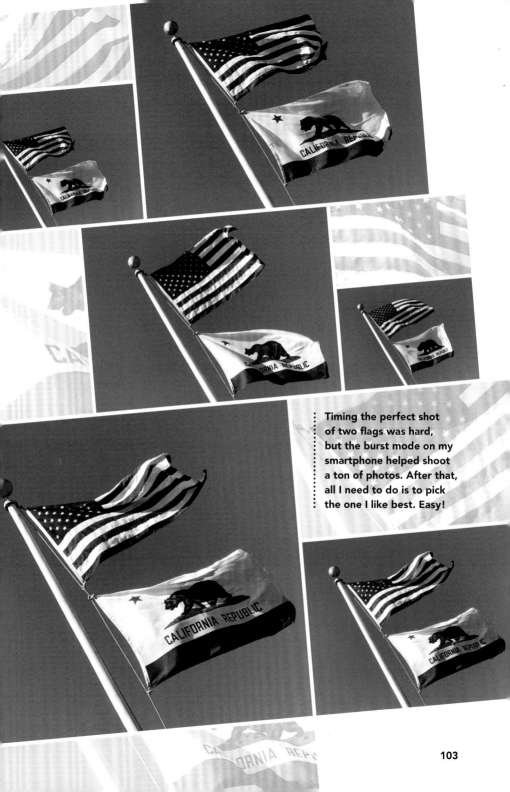

Timing the perfect shot of two flags was hard, but the burst mode on my smartphone helped shoot a ton of photos. After that, all I need to do is to pick the one I like best. Easy!

45 USE HDR MODE IN BRIGHT SUNLIGHT

Mobile phones usually have tiny image sensors. That's a problem in a few situations, most notably in low light (tiny sensors produce more noise than bigger sensors), and in extremely bright light.

When the sun is out in full force, photographers often have to make a choice: Are you going to expose for the shadows or the highlights? Mobile photographers have a third option: capture both using automatic high dynamic range (HDR). When you're taking photos in direct sunlight, turning on the HDR mode on your camera takes two photos in a row, one a little brighter than the other. It then digitally combines those two photos into one. That's great, because it means you get the best of both worlds.

If your phone has automatic HDR mode, you can save yourself a couple of taps, too—just leave it on.

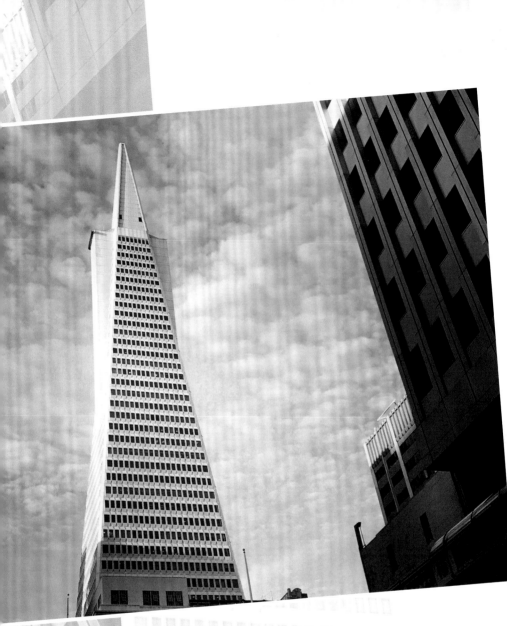

This photo of the Trans-America pyramid was fiercely hard to take... until I set the HDR mode on my smartphone. Check out both the bright areas around the tower and the dark areas in the foreground. Capturing all of those values would have virtually impossible until HDR came along.

46 CLEAN YOUR LENS EVERY DAY

If you're shooting with an SLR camera, you're probably spending a lot of time babying your lenses. You use your lens cap religiously. You protect your lens from bumps and scrapes.

Your mobile phone? Not so much. Luckily, most camera manufacturers know this and cover your lenses in ridiculously hard-to-scratch glass. That doesn't prevent your lenses from getting dirty, however, and you wouldn't believe what a difference even tiny specs on your smartphone lens make in your photo quality.

Smartphones have ludicrously poor battery life, so you probably charge your phone overnight every day. Add another step to your evening routine: clean your lens properly. A moist, lint-free cloth followed by some drying goes a long way.

If you're doing photography throughout the day, make sure to check your lens before you shoot, and clean it if necessary. You can buy microfiber cloths made especially for camera lenses—get one, carry it with you, and use it!

KNOW YOUR EQUIPMENT

Shooting in bad weather can produce some awesome, atmospheric shots, but make sure to wipe your lens to avoid big, fat blurry patches!

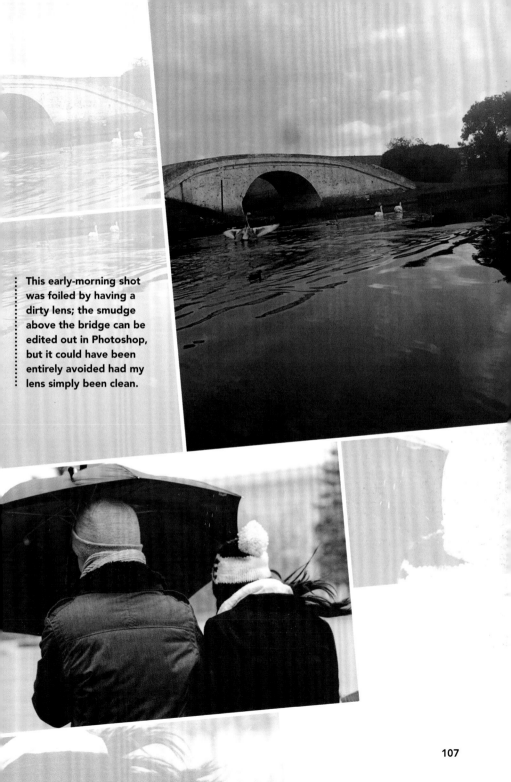

This early-morning shot was foiled by having a dirty lens; the smudge above the bridge can be edited out in Photoshop, but it could have been entirely avoided had my lens simply been clean.

47 BUT I DON'T HAVE PHOTOSHOP...

Even the finest photos can benefit from a little bit of editing. One of the greatest advantages of being a mobile-first photographer is that you carry enough processing power and a great screen around with you at all times. Use that to your full advantage. If you're using a "real" camera, you might consider some more advanced tools.

Photoshop is the undisputed champion of photo editing, and until recently it was very, very expensive. Adobe—the makers of Photoshop—changed their business model a while ago, and you can now have Lightroom and Photoshop for a low monthly fee.

Lightroom is a great tool for doing batch edits, keeping track of your photos, and building powerful photography workflows. Photoshop is a very powerful tool for retouching and advanced photography editing, plus specialized techniques like combining several photos, digital painting, and multi-layered photography. Lightroom for mobile, on the other hand, is easy to use, and free! The app is incredibly powerful and does non-destructive editing, which means that you never lose the underlying photo.

If you have serious ambitions as a photographer, however—even if you only shoot with a mobile phone—I recommend subscribing to Lightroom and Photoshop. Paying for access to the entire suite gives you a lot more tools and the ability to sync to your Lightroom library at home, so you can continue an editing process on your computer that you began on your phone.

It doesn't take a lot of editing to make a photo stand out. In this case, it was just a tiny bit of contrast, saturation, and color balance. All of 20 seconds editing in Lightroom—yes, definitely worth it!

This photo, of a sign in Tokyo, had something going for it. It was only after I increased the sharpness, vibrance, and saturation, and added a slight vignette that the photo fully came together, however.

48 BUT I DON'T WANT PHOTOSHOP...

Even at a low price, Adobe's photography suite can be a bit much for some people; or perhaps you just prefer a mobile-first editing app. Don't worry—if you don't need all the bells and whistles, you can get very far indeed with iOS and Android apps.

Instagram and EyeEm are both photo sharing platforms, but they are free, and they have surprisingly powerful photo editing tools built in. They're both good first ports of call for giving your photos that little something extra.

My other two apps for on-the-go photo editing are Enlight and Facetune 2, both made by Lightricks. The former is a photo editing suite that's easy to use and comes with a full set of tutorials. Facetune is also an editing suite, but it's focused specifically on making your portraits look great. It's a robust suite that includes great tools for portrait (and selfie) photographers that even Photoshop doesn't offer.

KNOW YOUR EQUIPMENT

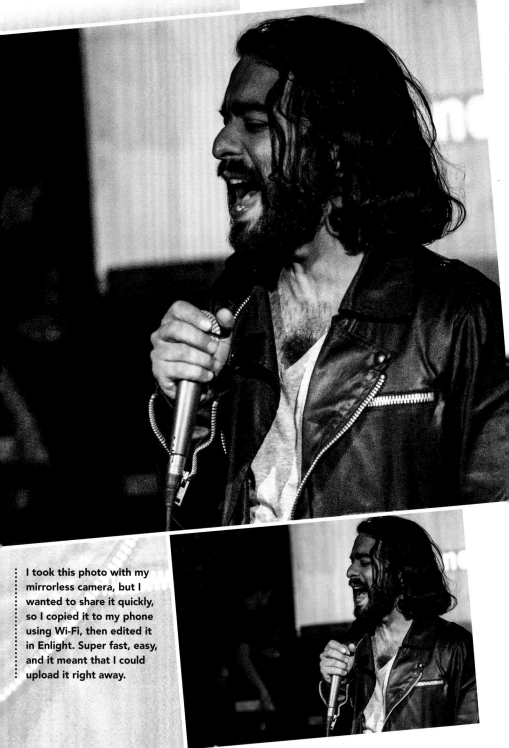

I took this photo with my mirrorless camera, but I wanted to share it quickly, so I copied it to my phone using Wi-Fi, then edited it in Enlight. Super fast, easy, and it meant that I could upload it right away.

49 | HOW DO I AVOID LOSING MY PICTURES?

Over time, you'll build up a library of photos. Some you'll prefer to forget, but many are super-cool photos that you'd hate to lose. So, let's try to avoid that, shall we?

I have my whole Lightroom library on Dropbox. That means it's automatically synchronized with the cloud, and if I lose or damage my computer, I won't lose my photos.

Sticking all your photos on Dropbox, iCloud, or one of the other cloud-based services is effective but expensive. An external hard drive is a great solution, but remember to also find some way of making sure backups happen automatically. It's too easy to forget to do backups, and external hard drives can easily break. I keep two sets of backups of my photos, on two separate hard drives. One lives in a drawer in my home office, and the other I keep in a drawer at work. That way, if someone steals all my computer stuff at home or (God forbid) the house burns down, I keep my photos.

Remember: you can insure your equipment, but if you lose your photos, they're gone forever. Back up your favorites accordingly.

KNOW YOUR EQUIPMENT

ioSafe makes backup solutions that are literally fire and water resistant. Their portable drives are basically indestructible—I know this because I managed to drive an off-road vehicle over my bag containing the drive. Suffice to say I'll never trust my image library to anyone else...

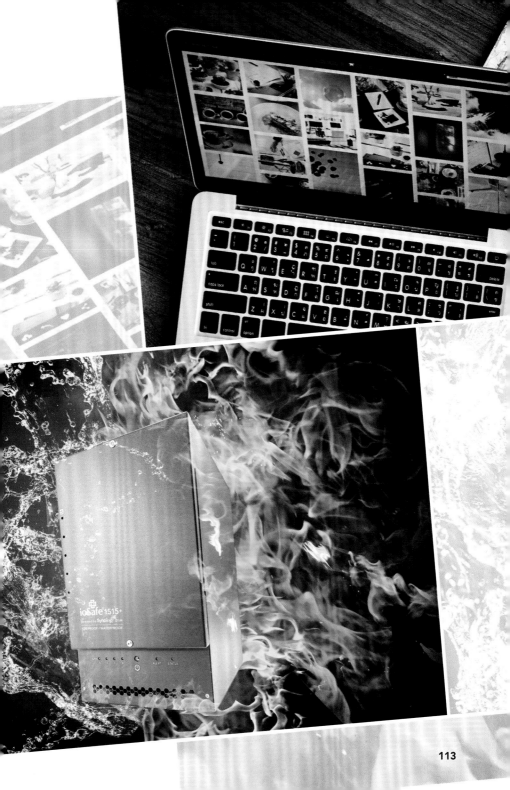

50 YOUR CAMERA IS A BETTER PHOTOGRAPHER THAN YOU

It took me a long time to learn this lesson, but I eventually learned that my camera is a lot better at taking photos than I am. Put differently, when it comes to taking great photos, my camera is rarely the limiting factor. I am.

Of course, occasionally equipment limits us. There are types of photography that are impossible with certain equipment—you can't use external strobes with an iPhone, for example (if you're determined to, check the Tric accessory). But the point of this tip is to drive home the point that your skill and intuition are far more important than your equipment. No matter how much you spend on photographic equipment, you could always spend more. Spending money is essentially a losing game. If you're going to spend cash, invest in practice, travel, and education—that way, you're investing where it really matters: your own skills.

KNOW YOUR EQUIPMENT

114

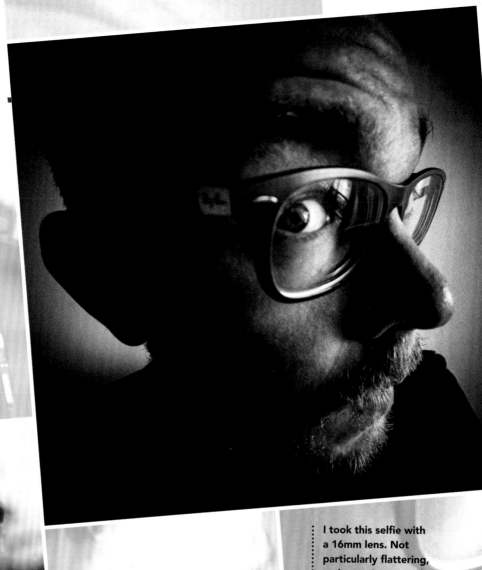

I took this selfie with a 16mm lens. Not particularly flattering, and more importantly, not properly in focus. It turns out it's hard to focus a 16mm lens when shooting at a short distance. Was it the camera's fault, though? Nope, just me being a numbskull.

PART FIVE

FINDING
THE PHOTOS

To take a great photo, all you need is a camera, some light, and something to take photos of. Before you book a one-way ticket to an exotic location, however, remember you can take great photos right in your neighborhood, or even in your very own home!

Sometimes just finding the inspiration for a photo can be hard. Hopefully the tips in this section will remind you that good photos are all around you; also that not every shot has to be—or will be, or even can be—perfect. And when you do have a photo you're proud of, what then? I'll also give you a few tips about sharing your endeavors!

5l THEY DON'T ALL HAVE TO BE AWARD-WINNING

I have several photographer friends who haven't taken a photo in months, because they can't wrap their heads around having to plan another successful photographic project. It's the danger of becoming a reasonably well-accomplished photographer, but then suddenly finding yourself under pressure to deliver again.

Don't be that person! Photography is a medium of creative expression and fun. As soon as it stops being fun (or if you run out of stories to tell), you've taken a wrong turn somewhere. One way to snap out of it, is to shoot differently for a while. Get a Polaroid camera, shoot only on your phone, take photos on film, whatever it takes.

It's much more important to keep taking photos regularly than to always be creating beautiful art. There's beauty all around you all the time, keeping an eye out for it is part of being a photographer. It's called "training your photographic eye," and it's something that is happening all the time, even (perhaps especially) when you're not holding a camera.

FINDING THE PHOTOS

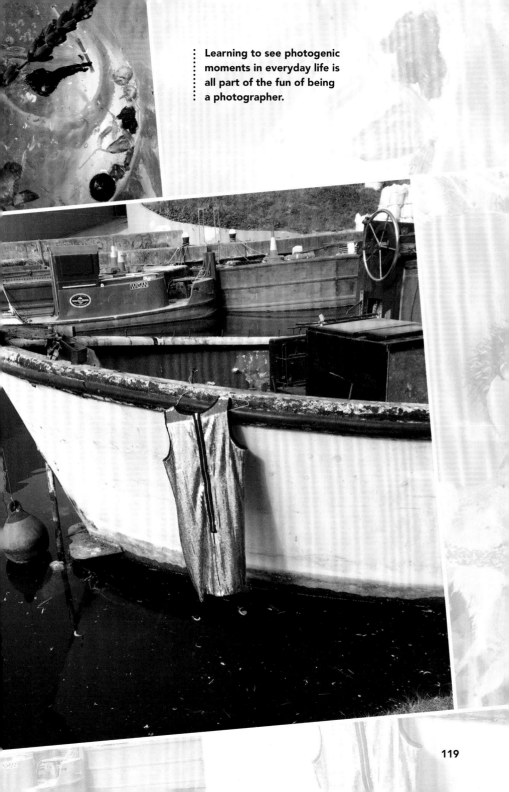

Learning to see photogenic moments in everyday life is all part of the fun of being a photographer.

52

HOW TO NEVER BE WITHOUT A CAMERA

You miss 100% of the shots you don't take, ice hockey legend Wayne Gretzky said. He's right: what good is your amazing camera if you leave it at home? The best way to ensure you always have a camera with you is to come to terms with the strengths and weaknesses of the camera built into your smartphone.

The camera is the main reason I upgrade my phone every year or so. Lens quality, low-light performance, sharpness, and in-camera post-processing are coming along by leaps and bounds, and every time I upgrade I'm amazed by how much they have improved. Phone manufacturers know this, too: they know that many people wouldn't buy a phone with a bad camera built into it, so they work hard to innovate from one product generation to the next.

If you really want to become a hot-stuff mobile photographer, try to do every tip in this book both with both a phone camera and a "real" camera. Or, hell with it, just do all of them with a cell phone camera (where you can—this won't work for the Film is Best tip!). You'll see your photos getting better very quickly, even with that most basic camera.

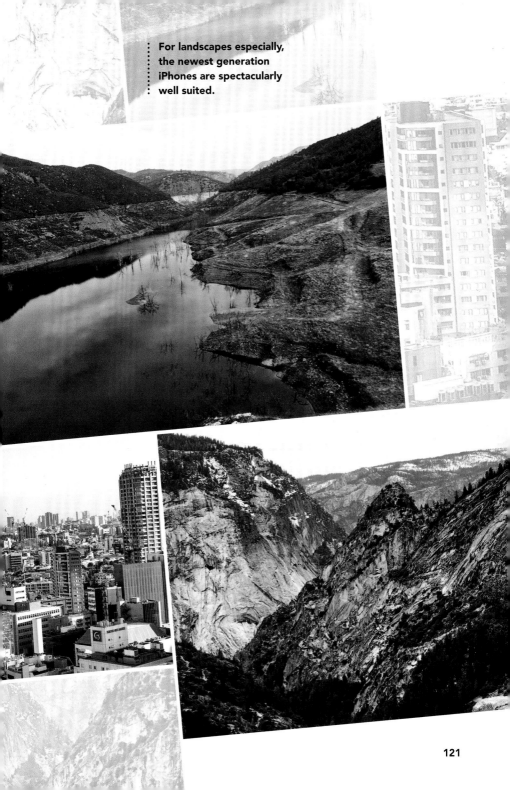

For landscapes especially, the newest generation iPhones are spectacularly well suited.

121

TOP TIPS FOR PLANNING A PHOTO TRIP

If you've been taking photos for a while, you'll probably have amassed some photo gear. Packing for a trip becomes a challenge: Should you bring a suitcase full of lenses, tripods, camera bodies, and accessories, or cut down for the benefit of traveling?

If you're shooting professionally, traveling with a separate case full of gear might be appropriate. Personally, I like the extreme limitations of traveling with a single body and a fixed-focus lens, but it is all down to what your expectations are.

My top tip for travel photography is to embrace the unknown. You'll end up in situations you didn't see coming, and chances are, you didn't bring a lens that's long or wide enough, or what have you. At that point, there are two things you can do: You can mope about it, or shrug and take the best possible photos with what you do have. Well, there's a third possibility: realize you don't have the right equipment, put your camera away, and enjoy being in a far-flung place.

The sheer variety of scenes you come across while traveling is both a blessing and a curse.

54 YOUR BEST PHOTOS ARE WHERE YOU ARE

When I first started taking photos, I assumed that it wouldn't be possible to take fun photos near where I lived. I thought I would have to get on a plane to some exotic location to get the best photos. Which, in retrospect, is silly. The area near where you live might be visually boring to you because you live there, but that is by no means a universal truth.

Taking photos in your local area has several benefits. For one, you're less likely to get lost. But more importantly, you'll be able to get home to edit your photos easily. If something doesn't go to plan, heading back out to take more pictures is easy. Don't write off your neighborhood; explore it with photography in mind, and you might be surprised that some of the most fun and vibrant photos are just around the corner. In fact, I bet you'll find that your familiar perspective gives the images a unique quality that an unfamiliar visitor could never capture.

FINDING THE PHOTOS

All of these shots were taken within a five-minute walk of my house. Keeping your eyes open, it turns out, goes a long way!

55 MAKE THE PHOTOS COME TO YOU

When you're starting to get the hang of portrait photography, you'll often find yourself setting up all your gear just to photograph one person. Pain in the backside? Yep. There's a way around that, though: Whenever you throw a party, set up your photography kit in the corner and run a fun headshots session for your friends.

It's a win-win: You get some extra photography practice, you'll be the life of the party, and your friends get some cool-looking photos for their social media. Of course, if you're feeling particularly lazy, you don't even really have to throw your own party—crash someone else's party and do the same thing! I've done this for several of my friends' birthday parties in the past and I can tell you it's great fun.

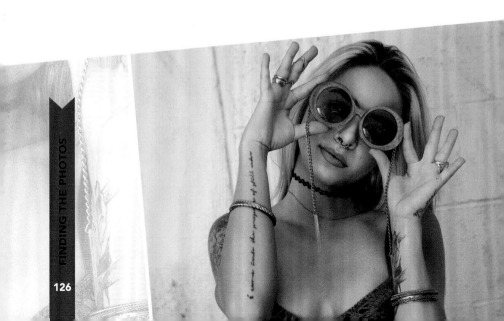

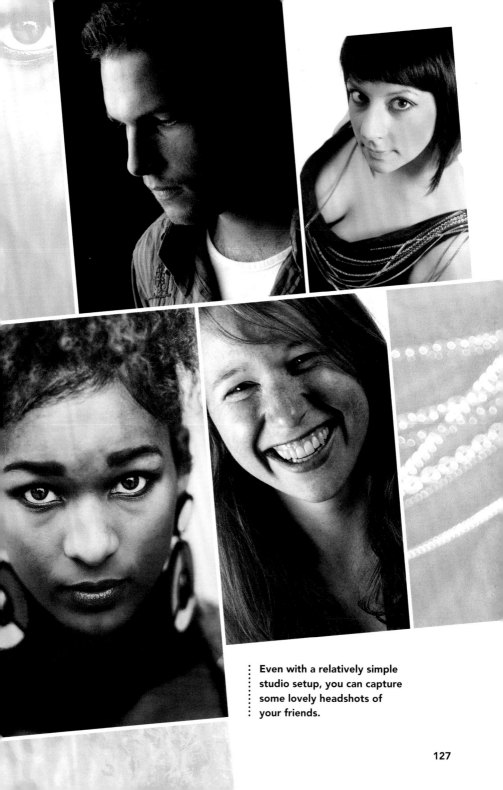

Even with a relatively simple studio setup, you can capture some lovely headshots of your friends.

56 MAKING PHOTOS VS TAKING PHOTOS

If you're a documentary-style photographer, the concept of "making" a photo might feel all wrong, but when you think about it, every photo is staged to a degree. Even if you're not moving or directing anything in your frame, you're still making choices around your photo. At the very least, you are choosing what to include and exclude from your photo.

From here, it's a small step toward making photos properly. There is a time and place for being a photographic purist, but I don't see anything wrong with moving a piece of litter out of the way or asking someone to study an apple at the market for just a few seconds longer. Ultimately, the frame you capture is about telling a story. All good storytellers know what needs to be done to nudge the narrative along a little bit.

Working with models is great practice for this, too, by the way. Models will generally do what you ask them—nothing more, nothing less. Directing your photography in a wider sense is important to your storytelling. Embrace it!

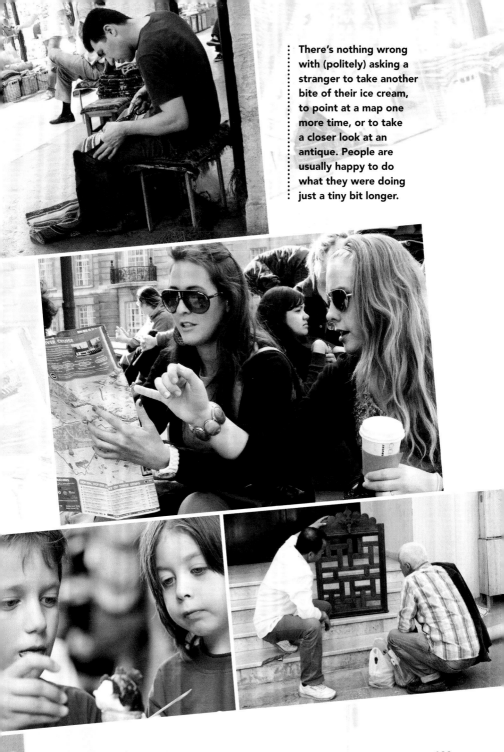

There's nothing wrong with (politely) asking a stranger to take another bite of their ice cream, to point at a map one more time, or to take a closer look at an antique. People are usually happy to do what they were doing just a tiny bit longer.

57 KEEP A BUCKET LIST OF PHOTOS YOU LOVE

It's a great idea to keep a scrap book (or, in these digital days, perhaps more like a scrap folder / Pinterest board on your phone or computer) of photos you really admire. My photographic bucket list comprises photos that I wish I could take one day. They serve as reminders of how far I've come as a photographer. Who am I kidding: They aren't. They're milestones in the distant future of things I still need to learn! But that, too, is helpful.

Other photos I save to my scrapbook include photographs that use techniques I admire or want to try at some point in the future. Perhaps a photographer uses a creative lighting technique in a shot, or maybe a makeup artist did something really cool with a model that I'd love to try on a future shoot. It's often easier to pull up a photo and say, "like that," than to try and describe a lighting setup or a particular pose to someone.

FINDING THE PHOTOS

Having got the basics of whichever technique you want to master (in my case, underwater photography), it's time to see what else you can do!

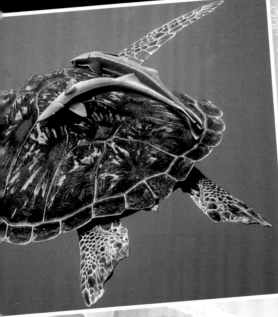

Underwater photography had an incredibly steep learning curve for me; a lot of the rules of photography simply don't apply underwater. When I was finally able to check "photograph a sea turtle" off my list, it felt like a major accomplishment!

GET SNEAKY—BE CANDID!

Candid portraiture is a fantastic way of capturing your subjects at their most natural. It's easiest if you shoot with a slightly long lens (I am a little bit in love with my 200mm lens for this sort of thing), but even if you're taking photos with a phone, you can capture people unawares. The trick is to use your eyes a lot more than your camera. Spot situations, poses, and expressions that you think capture the personality of the person you're photographing. Once you think you've got it, try capturing it with your camera.

A great way to practice this is to head out into the streets and take photos of complete strangers. A busy market is great; there's so much going on that nobody has time to pay attention to what you're up to with your camera. Known as street photography, capturing the everyday lives of strangers is challenging, but it can tell the story of a city and its inhabitants really beautifully.

FINDING THE PHOTOS

When you're out and about, always be on the lookout for a good shot. This photo at right has loads of personality in it, plus all that pink makes for a really pleasing image!

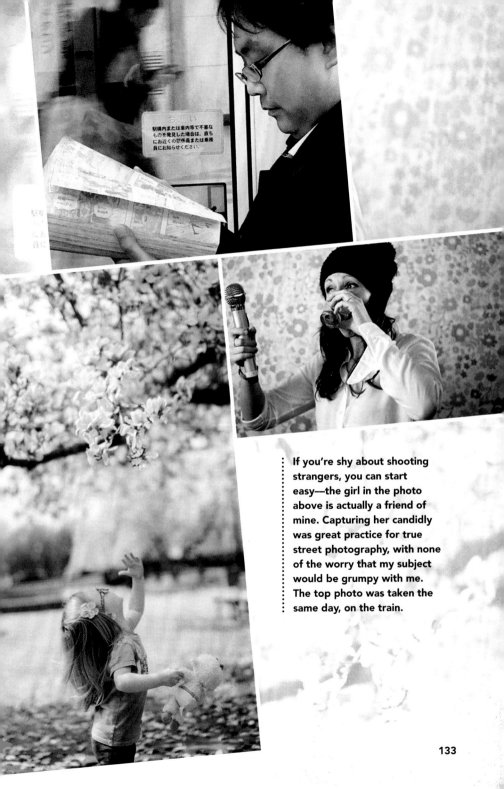

If you're shy about shooting strangers, you can start easy—the girl in the photo above is actually a friend of mine. Capturing her candidly was great practice for true street photography, with none of the worry that my subject would be grumpy with me. The top photo was taken the same day, on the train.

133

59 | GET SOCIAL

While there are indeed some sacrifices regarding image quality with mobile photography, there is one huge advantage: your photos are stored on a device that has an internet connection, and sharing your photos is very easy indeed.

I would suggest you start building up your own little photography community on social media, whether on a photography-based network (such as Instagram, EyeEm or Flickr), or a social-based one (Facebook, Twitter). It's great fun to learn more about photography with some of your friends, and the speed at which you can get feedback from friends and complete strangers is invaluable.

Oh, and I'd love to stay in touch with you. Show me your photos, please! I'm @Dipsolect on Instagram and @Haje on EyeEm and Twitter. Come hang out, we can have virtual beers and share stories about some of our coolest photos!

FINDING THE PHOTOS

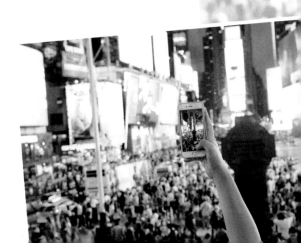

Fair warning—following me on Instagram will result in a lot of cat photos. Luckily, there are more interesting people than me you can follow, too!

60 GOOD ENOUGH IS GOOD ENOUGH

One of the common challenges I come across with new photographers is a reluctance to show any of their work to the outside world, because nothing they do is perfect.

I'll let you in on another secret: I have never in my life taken a perfect photograph. I mean, I've taken some pretty good ones, but there are always things I could have done to make them that little bit better. Perhaps a pose could have been different. The light might have been slightly brighter. The focus should have been a smidge sharper. Or sometimes, everything comes together technically, but the story fails to evoke the emotion I felt when I took it.

The point here is to let good enough be good enough. If you're chasing perfection, you'll be searching for a very, very long time.

Count your blessings, celebrate what's good about your photos, and share your progress with the world.

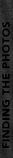

I'm not much of a wildlife photographer, but there's something about having captured this bird that fills me with pride. It was a fiercely hard photo to get, and if I had another chance, I'd have loved to have more of it in focus. But is it good enough to print in a book? I guess so—it's right there on the page!

61 | EVERYONE HAS AN OPINION

As a keen photographer, you're stuck in a world between valuing your own artistic vision, and trying to get feedback on your photos. Both are important; learning how to self-critique better is one of the most powerful tools toward better photography, but it's also true that everyone will occasionally miss something really obvious about their own photos.

Don't be shy about asking for feedback, and don't limit who you are seeking feedback from too much. Photographers can give you pointers on the technical aspects of your photography, but anyone can give feedback from a viewer's perspective.

"Imagine this photo tells a story," you can ask. "What story do you think it tells? How does it make you feel?" The replies can help you determine whether or not you're hitting your mark, telling the stories you want to tell.

This photo has some good things about it, and some bad ones. It means a lot to me, because I know where it's taken and who's in the photo. Does it work as an artistic expression? I'm not sure, but that's why asking other people can help fine-tune your photography.

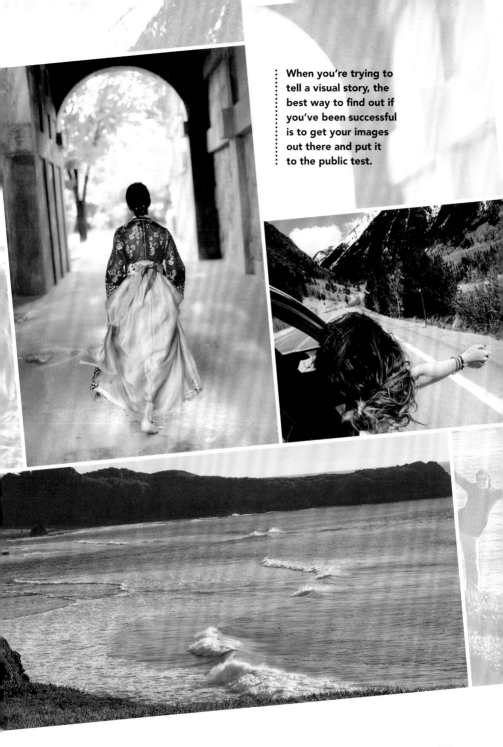

When you're trying to tell a visual story, the best way to find out if you've been successful is to get your images out there and put it to the public test.

62 IT ISN'T REAL UNTIL IT'S ON SOMEBODY'S WALL

A good yardstick for success is whether people like your photography well enough to hang it on their walls. It feels pretty archaic, perhaps, but it's very easy to like a photo on Facebook or Instagram and move on. We have an infinite number of likes, after all, but a limited amount of wall space, and money.

"Would you pay me $50 to print and frame this photo and hang it on your wall?" This question is, in many ways, the perfect measure of success. A "yes," and especially if the person you're asking enthusiastically reaches for their wallet, is the one sure-fire confirmation that your photography is striking a chord with your audience.

If you're not feeling bold enough to ask others to pony up for your photographic output, try printing some photos for yourself. Give them away as gifts, or hang them on your own walls. It's a milestone. Celebrate it!

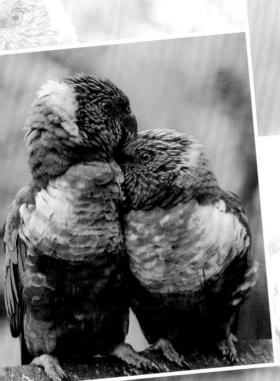

Two photos. Both of birds, both in focus, both well lit. One of them tells a story; that's the one that's proudly hanging on my wall. And, given that I licensed it to a large, well-known furniture store, probably a few hundred other people's walls, too.

INDEX

ACKNOWLEDGMENTS

Picture Acknowledgments
The publisher would like to thank the following for permission to reproduce their material:

5, 80, 92: Aidan Hancock/Unsplash; 8–10: Benjamin Baláz/Unsplash; 11(BL): Jon Tyson/Unsplash; 14: Mark Finn/Unsplash; 18: Angello Lopez/Unsplash; 19 Alphotographic/iStock; 25: Federico Bottos/Unsplash; 26: Recito Prasida/Unsplash; 27(BL): Tanja Heffner/Unsplash; 27(T): Alexandru Zdrobau/Unsplash; 28: Chad Madden/Unsplash; 29(T): Quin Stevenson/Unsplash; 29(BL): Roksolana Zasiadko; 30, 46, 114: Jakob Owens/Unsplash; 31, 42: Jay Simmons/Unsplash; 32–33: Nicolas Barbier Garreau/Unsplash; 34: Rawpixel.com/Unsplash; 35(T): Aral Tasher/Unsplash; 36: Patrick Tomasso/Unsplash; 37(T): Peter Hershey/Unsplash; 37(B): Polina Flegontovna; 38: Jamie Street/Unsplash; 45: Bonnie Kittle/Unsplash; 49(B): Tanja Heffner/Unsplash; 50, 54: Jakob Owens/Unsplash; 51, 52: Dreamstime; 56–57(M): Mitch Rosen/Unsplash; 56–57(B): Zachary Staines/Unsplash; 57(B): Kari Shea/Unsplash; 59(TL): Joshua Reddekopp/Unsplash; 59(B): Rachel Silverlight; 60(L), 116: Adil Ansari/Unsplash; 61(TL): Svetlana Pochatun/Unsplash; 61(TR): Alex Sheldon/Unsplash; 61(B): Autumn Goodman/Unsplash; 63(T): Janko Ferlic/Unsplash; 64: Annie Spratt/Unsplash; 66–67(B): VisionWebagency/Unsplash; 68: Guillaume Bolduc/Unsplash; 69(BL): Eli DeFaria/Unsplash; 70: Eaters Collective/Unsplash; 71(B): Annie Spratt/Unsplash; 72(TL): Peter Hershey/Unsplash; 72(TR) Kit Junglist/Unsplash; 72(BL): Jiawei Chen; 72(BR): Cameron Kirby/Unsplash; 73(C): Annie Spratt; 73(BL): Asaf R/Unsplash; 73(BR): Kendra Kamp/Unsplash; 74: Alexandru Stavrica/Unsplash; 76: DKart/iStock; 77: DKart/iStock; 78: Cole Keister/Unsplash; 81(B): Chris Barbalis/Unsplash; 82, 96: Evan Wise/Unsplash; 83, 100: Jakob Owens/Unsplash; 86: Oktay Ortakcioglu/iStock; 87(TL): Danielle Peterson/Unsplash; 87(B): Ralph Evans/Unsplash; 88, 110: Kane Reinholdtsen/Unsplash; 93(B): Max Kaharlytskyi/Unsplash; 94: Cherkas(TL): Rosalind Chang/Unsplash; 97(B): Warren Wong/Unsplash; 98: Andrew Branch/Unsplash; 99(B) Amanda Kerr/Unsplash; 104: Sebastien Gabriel/Unsplash; 106: Carlos Santiago/Unsplash; 107(B): Pavel Badrtdinov; 113(T): Rawpixel.com/Unsplash; 113(B): ioSafe.com; 107: Rachel Silverlight 114–115: Chantel Lucas/Unsplash; 117, 122: Lily Rum/Unsplash; 118: Rachel Silverlight; 119(B): Rachel Silverlight; 123(B): Quentin Leclercq/Unsplash; 126: Atikh Bana/Unsplash; 127(BL): Anter Blackbird; 130: Jakob Owens/Unsplash; 130–131: Christopher Campbell/Unsplash; 131(TR): Martin Sattler/Unsplash; 132: Thomas William/Unsplash; 133(BL): Karl Fredrickson/Unsplash; 134: Blake Wisz/Unsplash; 135(B): Rawpixel.com/Unsplash; 136–137: Joao Silas/Unsplash; 139(TL): Adamara/Unsplash; 139(TR): Averie Woodward/Unsplash; 140: Crew/Unsplash.

Every effort has been made to trace copyright holders and to obtain their permission for use of copyright material. The publisher apologizes for any errors or omissions in the list above and will gratefully incorporate any corrections in future reprints if notified.